REFLECTIONS ON WATER

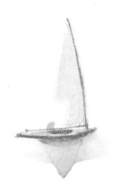

ART TECHNIQUES · WATERCOLOUR
REFLECTIONS ON WATER

ETTORE MAIOTTI

B⬗XTREE

For Luciano Gussoni,
whom I consider to be
the greatest living painter.

First published in Great Britain in 1993 by Boxtree Limited.

© 1993 Gruppo Editoriale Fabbri, Bompiani, Sonzogno, Etas S.p.A.

The right of Ettore Maiotti to be identified as Author of this Work has been asserted by him in accordance with the Copyright, Designs and Patents Act 1988.

10 9 8 7 6 5 4 3 2 1

Translated by Kerry Milis Parker
Edited by Art, Bologna - Italy
Designed by Studio Maiotti
Typeset by Art, Bologna - Italy
Printed and bound in Italy by Gruppo Editoriale Fabbri S.p.A., Milan.

Boxtree Limited
Broadwall House
21 Broadwall
London SE1 9PL

A CIP catalogue entry for this book is available from the British Library.

ISBN 1 85283 502 8

CONTENTS

INTRODUCTION

I did my studies at the art college in the Sforzesco Castle in Milan in the sixties and seventies when the architect Boattini was director. I was a student of the great Luciano Gussoni under whom I continued to study for another ten years, enriching my experience in a way that I could never have duplicated anywhere else. I was also lucky enough to study fresco painting under the memorable Virginio Bertazzoni, an inimitable fresco painter, now dead and forgotten by everyone except his old students.

I have strong memories of those days and especially of those two teachers: their discipline, their talent, which we all benefitted from, and the way they lived, sure of their craft, indifferent to commercial trends in art, ever faithful to the old traditions of the painter and his workshop.

Today, no trace of this old-fashioned way of teaching painting remains at my school. Now it is just one school among many.

I do not want to discourage young people who want to follow an artistic path. I only regret that they will probably not have the same possibilities that I had when I was a student, eager to learn everything I could about painting.

In those days my teachers knew their craft with the mastery of artisans and they were not afraid to pass this knowledge on to their students with an enthusiasm that made "believers" out of us.

I remember the classes taught by the sculptor Russo, another one of that now forgotten group. Every word he spoke was for me and the other students engraved in our memories. During drawing class there would be complete silence in the studio, the only sound was that of pencils

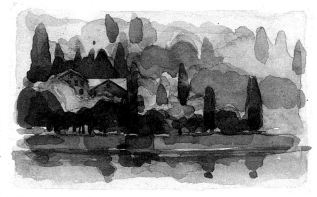

Ettore Maiotti
Lake Molveno (actual size).

moving across paper. We did not feel like artists yet, only students.

At the end of our classes each day the professors would join us students and we would finish the afternoon in an old tavern (today replaced by a fancy fast food bar).

Over a glass of wine and a hearty sandwich, our teachers would talk to us of Michelangelo, Masaccio, Klee, Malevich, and Pellizza da Volpedo.

We were immersed in stories about their lives, their sacrifices and their poverty, made tolerable only by the richness of their inner lives.

They told us emotional anecdotes of the hardships these great painters had to endure to go on painting, they related stories of the wretched lives of painters like Van Gogh and the martyrdom of his madness.

They would get excited as they told us details to help us understand them better and admire them more. We virtually lived the lives of these painters ourselves and talked about them constantly, so grand was their work.

That school, those teachers, created in us students such a strong group spirit that we became inseparable. We were always happy together and after we finished our course we rented some workshops in old Milan where we worked tirelessly.

It was in such a studio in the attic of an old house on the via Canonica that I began ardently to want to dedicate my life to painting and to begin to put body and soul into my decision.

I drew endlessly: anatomy studies, still lifes and life poses with real models, young and old, nude and

clothed. I was never satisfied with my work, I always wanted it to be better.

In those days I did not have much interest in painting outdoors. I was put off by the idea of going out to the country with palette and paints, sitting down and then being surrounded by curious onlookers. It was only after several years that landscape began to fascinate me, at a time when my painting was veering towards the abstract. I seemed to be looking for a depth that only landscape could fill. Mondrian's studies of trees also influenced my decision.

I would wander through the countryside with my box of paints and brushes and I would stop wherever the landscape struck my fancy. I first began to work on a small scale, thinking this would be easier but it was not true. Big or small, every painting has its difficulties.

My search for solitude took me to the banks of the canals and rivers where the silence, the light and the colours reflected in the water created visions that delighted me.

Anything that disturbed the water – from the dropping of a stone to a gust of wind or a small current – would modify its mirror-like surface, creating infinite variations in its reflections, and I would stand mesmerised as I tried to figure out the secrets of each small change.

I have always been very self-critical and even after years of experience, each time I paint it feels like the first time and I am never wholly satisfied.

Perhaps it has been this dissatisfaction that has pushed me ever onwards to discover new roads. Some of my discoveries I would like to share with you.

In this handbook I want to try to give you a wider vision of painting and watercolours, one that goes beyond the purely figurative.

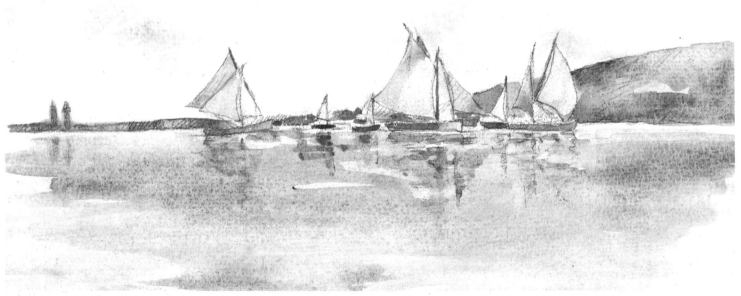

Luisella Lissoni - Travel Note (actual size).

THE RICE FIELD

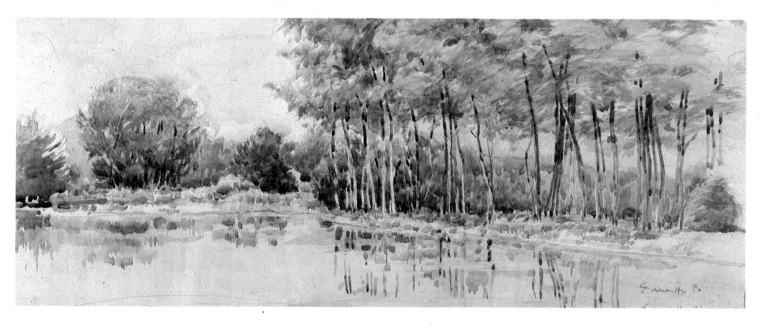

Ettore Maiotti - The Rice Field (40 × 14 cm).

I do not know if you have ever seen a rice field in late spring, but it is such a beautiful sight that I urge you not to miss it. In spring the rice fields are planted and then flooded with water which remains stagnant, immobile, for about a month, only the surface moving every now and then, rippled by a gust of wind or a frog jumping out of the water.

My early roamings would often take me to the shores of such a rice field and frequently I would go to my friend Beppe's house.

He lived in a small village in Lombardy near the rice fields. At sunset it felt as if I were enveloped in an impressionist painting. It was so compelling that I would suddenly feel the urge to paint.

Immediately I would go and prepare some frames with paper, using a method mostly forgotten these days. I would like to share it with you.

With this system it is possible to use lightweight paper without running the risk of it curling up. I had with me some "Ingres" type paper which is not normally used for watercolours but it can nevertheless give good results if you prepare it as I suggest. Before you begin make a small cross with a pencil on the right side of the paper so that once you have wet it you will be able to tell which side is which.

Get hold of the kind of frame normally used for stretching canvases for oil painting and then cut the paper so that each side is a few centimetres wider than the frame. Now soak the paper in a tub of water for about five minutes.

Next, you will need some vinyl based glue (do not use any other kind because it will not work as well). Squeeze some out along

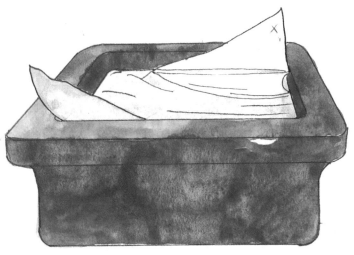

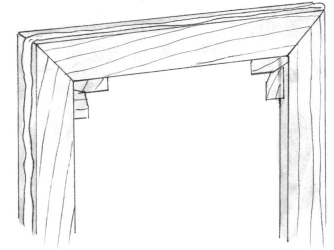

the outer edges of the frame and spread it uniformly, especially around the corners.

Centre the paper as carefully as you can over the frame, so that there is the same overhang on all four sides. Then press the

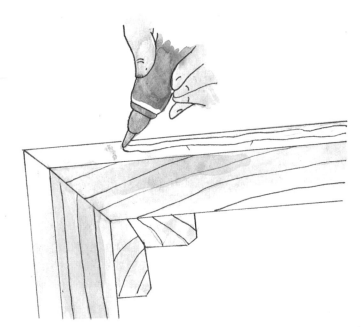

paper onto the glue and keep an eye on it while it dries to be sure it does not come unstuck.

If it does, press it down again immediately with your fingers making sure it stays attached.

When the paper is completely dry, it will look like the picture below.

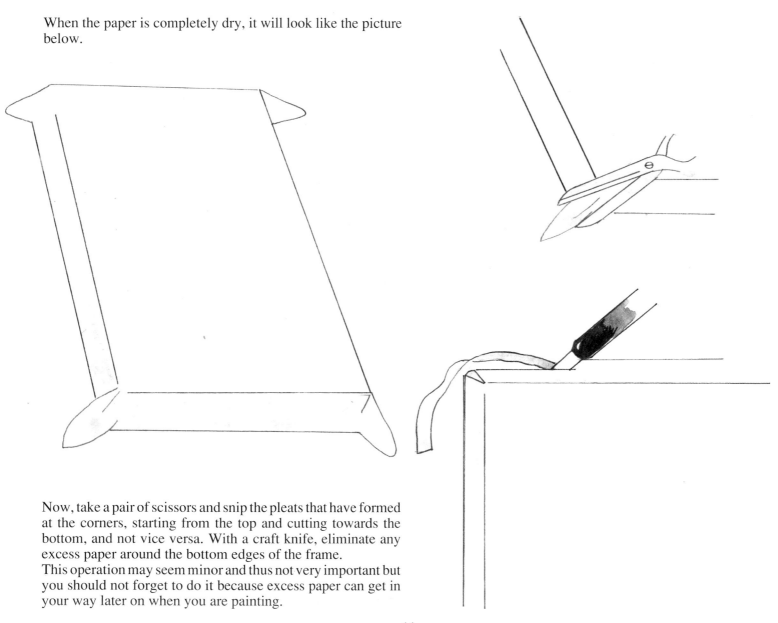

Now, take a pair of scissors and snip the pleats that have formed at the corners, starting from the top and cutting towards the bottom, and not vice versa. With a craft knife, eliminate any excess paper around the bottom edges of the frame.
This operation may seem minor and thus not very important but you should not forget to do it because excess paper can get in your way later on when you are painting.

Before you begin to paint your landscape, it is important to know something about perspective. Remember that you are working on a surface that has two dimensions (width and height) and you are trying to reproduce the effect of a third dimension (depth) by creating an optical illusion which we call perspective.

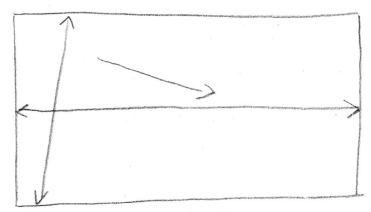

Bearing in mind the original meaning of the Latin word *prospectiva*, "to see clearly", I would say that in order to understand perspective you must first learn to see, by studying both real landscapes and those in paintings.

One way to understand perspective in nature and the concept of the vanishing point is to stand in the middle of a long road and look straight ahead: the point where the two sides of the road seem to join is called the vanishing point.

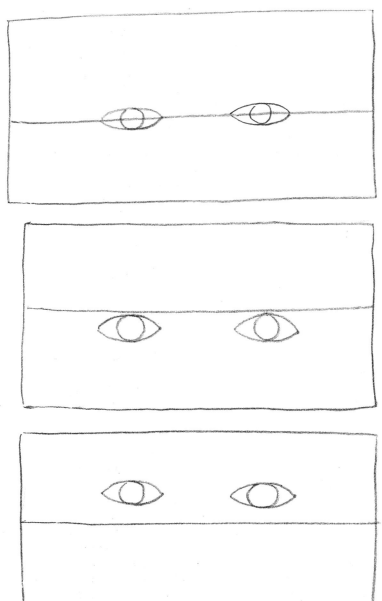

Remember that the image you paint should produce the same feeling as the one you see: that is what you are trying to capture on paper. To achieve an exact perspective, you should always draw the image with the aid of horizontal and vertical construction lines.

Following these rules, which are used by all landscape painters, you can draw your subject correctly even without an in-depth technical knowledge of perspective.

Now then, the first line you must draw is the horizon line. If you are standing, it will always be at the same level as your eyes and should be placed at the centre of your sheet.

If you are working from a sitting position, the horizon line will still be at eye level but you should place it a little higher on your paper.

If you are sitting on a balcony or a terrace, the line of the horizon should be a little bit lower on your paper.

Look carefully at my painting on page 9. The horizon follows the line where the undergrowth starts.

To make the execution of a drawing like mine simpler, I will explain the different phases of landscape drawing to you in order, from the beginning.

As you read the explanations, look at the drawings on pages 14 and 15.

For this painting, I was sitting on top of a small hill which meant that the horizon was slightly lower with respect to the centre of the sheet and coincided with the base line of the undergrowth.

The right side of the edge of the rice field formed a diagonal line that went from right to left to meet at a vanishing point slightly towards the left (page 14, above).

You must learn to "see" the vanishing point within your preparatory drawing, imagining the line of the horizon. Try to arrive at a juxtaposition of colours with the first perspective construction lines of your drawing (page 14, below).

If you can reach a good optical equilibrium, you will feel more satisfied because you will have achieved two important aims. Besides a harmonious beginning to your drawing, you will have taken a small step towards the understanding of abstract painting. Bear this in mind when you want to begin an abstract study of the kind that Mondrian inspires. In such a case you would start from a realistic figurative study and gradually make it more abstract.

But let us return to the "rice field".

After the first stage, outlined above, I moved on to sketching in the lines that trace the growth of the trees and bushes with a pencil and also drew their reflections in the water (page 15).

As you may notice, everything that is on the same plane gives the impression of meeting at the vanishing point. Even the reflections in the water give the same impression and the reflected vanishing point meets at the horizon.

This second phase may also remind you of an abstract painting. Notice the interpretation I made which inspired me to continue with the drawing (the last of the sequence on page 15, below).

After my initial study, I became more involved with details and using a pencil I drew irregular geometric shapes. Now the drawing that began to appear was more realistic and any further link with abstract interpretations became impossible. Successively I became more preoccupied with detail. I created shadows following the movement of the foliage and the points where they appear darker (see page 17).

I have tried to explain stage by stage how I developed my painting but I want to emphasise that the procedure is never mechanical and that the various stages should be intertwined harmoniously, like the sound of various instruments in a concert.

Once you have reached this point, you can begin the delicate phase of preparing your palette. Do not underestimate the importance of this phase.

For the watercolourist, the arrangement of colours is very important whether you are using watercolours in pans or tubes. If you prefer to work with pans of paint, start with an empty box and choose and arrange the watercolours in your box in the order you prefer.

Remember that every painter, through experience, creates his own palette.

Some artists work more often with earth colours, some use a

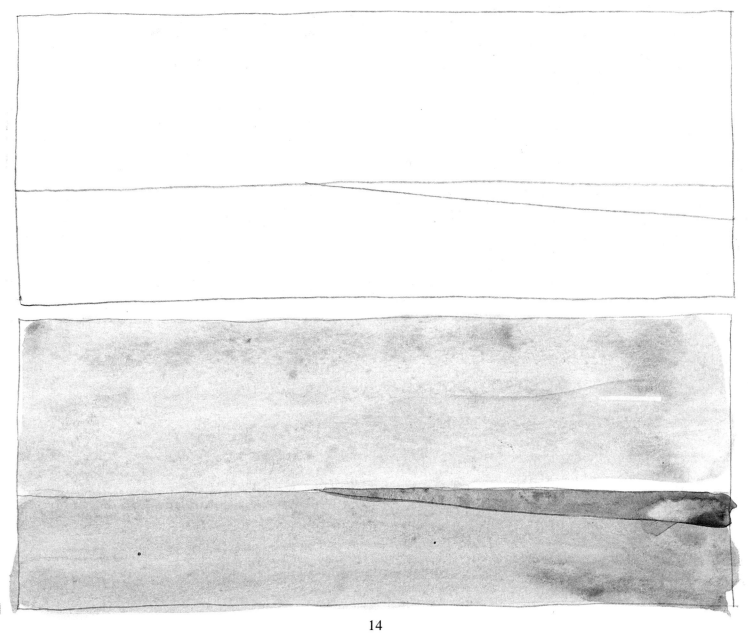

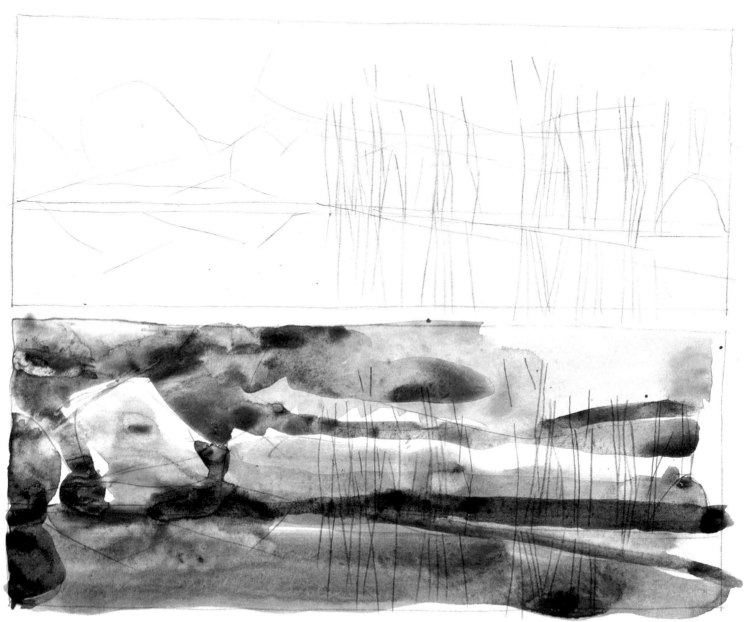

15

great deal of green, while others use lots of yellows. But it is important to get into the habit of always arranging your colours in the same way so that this operation becomes automatic. Even if you do not expect to use them, always prepare all the colours in your range.

Since you cannot anticipate what you may need, it is best to have the whole range of watercolours ready to hand.

This way you will not need to interrupt your work constantly. When you are going to paint, keep this in mind. It is important to be able to work without interruptions that constantly force you to start all over again.

I know many painters, both professionals and amateurs. The former distinguish themselves from the latter by the amount of time and care that they put into the preparation of their palettes.

This is not time wasted because the palette is already a painting. Think of the patience with which a fisherman prepares his lines and waits for the fish to bite.

You must never be in such a hurry to start that you do not do your preparatory work carefully.

I do not want to become a nag, constantly reminding you to keep this in mind.

I will only tell you that, for every one of Bonnard's paintings, he had a wooden palette that he divided into many small squares, and in each one he put a colour with its cooler and warmer tones next to it, before he put anything on his canvas. When he finished working, he had a palette painted in small coloured squares, placed harmoniously together.

Klee applied this synthesis directly to the canvas, inspired by very precise ideas.

Should you wish to find out more about these, you can by reading his theory on form and figuration.

As for me, when I arrange my colours on my palette I follow this rule: for large scale landscapes, I use watercolours from a tube and, as a palette, a large white ceramic tile, the biggest one I can find.

I then proceed as follows: in one corner I put ultramarine and in the opposite corner I put carmine.

Between these two corners I put cadmium yellow pale (if it is too dark I use primary yellow).

Then, on the side between blue and yellow along the perimeter I arrange first the blues and then the greens putting the darker greens closest to the blue and the lighter greens nearer the yellow.

Always place your colours as close to the edge as you can so you leave yourself as big a space as possible in the middle of your tile in which to mix your colours.

The blues I use are prussian blue, cobalt blue, and cerulean blue. My greens are sap green, emerald, cadmium green, terre vert, veronese green and permanent green. These, mixed with a blue, a red or a yellow give me, according to my palette, the full range of colours that I need.

There are also other greens in tubes that you can add to the range that I have chosen, or you can substitute as you like, but always keep in mind that sap green and emerald are indispensable.

Between cadmium yellow and carmine I arrange the gamut of oranges and reds: magenta, crimson lake, cadmium red pale, cadmium orange, chrome yellow deep, cadmium yellow.

These colours when mixed with blue or yellow give an important range of variations.

On the tile at this point there are still two free sides.

Next to the blue, I lay down a range of dark blues and violets, cobalt violet and indigo blue. On the remaining free side, next to carmine I put the browns and earth tones in this order: vandyke brown, burnt umber, burnt sienna, raw umber, raw sienna and yellow ochre pale.

Let's look now at the colours used in my painting.

Watercolour is a medium in which the use of white paint is forbidden. Maximum luminosity comes from the white of the paper which, where there are patches of light, is left as is, without colour.

Begin from the darkest areas, that is, where the shadows are darkest and work with a grey called "bistre".

Bistre is the painter's black, prepared by many artists and used in place of black from a tube which, if not used properly, does not darken colours, but just makes them looks dirty.

16

You can make bistre by mixing together equal parts of ultra-marine, cadmium yellow pale and carmine;

17

or by mixing burnt umber with ultramarine.

Complementary colours (yellow-violet, red-green, blue-orange) mixed together also make bistre.

For my painting, I made bistre with burnt umber and ultramarine.

Use a bit more ultramarine than burnt umber to give the painting a bluer feel (see page 19).

Getting the zones of shadow is not always easy with bistre because one tends to use too much colour. You should begin with light touches of very diluted colour (it should look like dirty water), following the shadows you outlined with your pencil.

Here is the way to do it: put down a very small amount of colour, then dry your brush a little, and dip it into clean water. Now with the tip work the water into the bistre, shading it towards the white areas of the paper.

Remember that watercolours are washed on with water so do not be afraid to use it. You should get used to diluting the colours. Otherwise they will appear too dense and heavy, giving the painting more the effect of tempera.

To decide whether you have diluted your colour enough, look at it closely: you should be able to see the sketch lines through it. In the next phase I began to work with the greens of the trees. As you can see, there are three tones of green with their respective variations.

A cool green can be achieved mixing a little ultramarine, cadmium yellow and sap green,

18

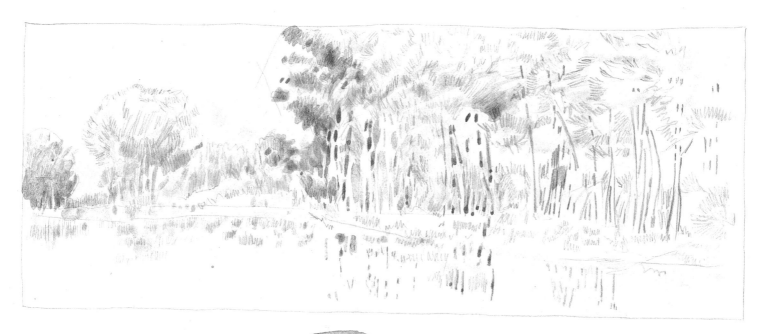

or emerald green and carmine

or cerulean blue and sap green

or terre vert, cadmium yellow and
ultramarine.

With this green I painted all the zones of half shadows, going back over the bistre as well, which had dried by then. In the lightest zone, the places where the sun shone brightly, I added a little cadmium yellow and pale ochre to my green.

As I touched in the colour with the brush, I left white spaces where the leaves in full sunlight seemed to reflect the sun like a mirror.

The grass in shadows behind the undergrowth and the darkest parts of the tree trunks I painted using the same logic. Everything that has depth, is farthest away or dark, has a cool tone. The absence of light leads us towards the azures, the blues, the violets, the indigos and finally black. A sense of depth is also created with this same play of colours: a far-off mountain seen during the day will appear bluish, at night it will be blacker than the sky. Using this logic in the laying on of colours, I tried to give the effect of depth to the plane where the grass grows. Trying out the azure greens first, I realized with the first wash that they did not give it enough depth although the tones were correct.

I quickly recalculated, remembering how Cézanne had solved such a problem: the green in the foreground of the trees had some yellow ochre mixed with it so a greater sense of depth could be achieved by adding some violet to the foliage farther away. This is because violet is the complementary colour of yellow and the two colours repel each other optically.

Thus the yellow-green seems to come forward in the foreground while the green-blue-violet seems to recede.

A few transparent strokes of burnt sienna help to separate them from the more intense greens of the foreground.

Green violets, or rather these green violets, are made by mixing cobalt violet and emerald
or alternatively emerald, ultramarine
and carmine. There are also other chromatic alternatives for these particular colours.

You will begin to discover such combinations yourself through trial and error, as you find your way around your palette.

Tree trunks are never one single colour and they are never brown as so many painters paint them.

They may be grey or, in full sunlight, blue grey; they may be a rosy or reddish colour; and when seen through foliage, they become a rather dark grey obtained by mixing burnt umber with ultramarine.

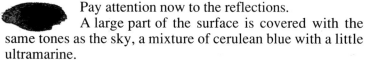

In some cases, indigo and burnt sienna work best, and at other times they can be painted with a mixture of terre verte and vandyke brown, or even with raw umber and ultramarine.

Pay attention now to the reflections. A large part of the surface is covered with the same tones as the sky, a mixture of cerulean blue with a little ultramarine.

You should wash this tone over the entire rice field.

Then where the water is not disturbed by small currents and reflects colours exactly, add more of the sky colour.

One more bit of advice: the light greens should not have too much yellow added to them. They should be diluted with a lot of water and then a little yellow should be added to them, followed by a little light ochre and finally more water.

For any skies that you paint, no matter what shade of blue you use, add a tiny bit of primary red (magenta) or, better yet, carmine.

THE RIVER AMSTEL BY PIET MONDRIAN

When working with watercolours it is important to keep one's colours simple and avoid overpainting. One does this by having a sense of when the painting is finished or, rather, when it ought to be.

Many watercolourists, especially beginners, tend to go on and on, laying on colour until the painting ends up with a heavy look and has lost its luminous character.

One of the first rules, basic but fundamental, is this: the pencil lines should always be visible through the paint. This watercolour by Mondrian was achieved with very few tones of colour and it is useful to see how the artist did his drawing and what kind of paper he used. Among other things, one notices the size of the paper, 69 by 110 cm, unusual for a watercolour.

Mondrian liked to experiment. He was less concerned with the kind of materials he used than with the results. In this case, for example, looking at the yellowish colour of the paper, one would guess that he had used a woody paper with little rag content, something cheap like sketching paper or maybe even the wrong side of a piece of white packaging paper.

All are papers that will yellow with age if they are exposed to the light but the results are very attractive from a pictorial point of view.

This shows that quality is not always the most important element when you are choosing the kind of support to use. We can see here that using a so-called "cheap" paper has actually improved the final results.

But we can only guess at this since we cannot actually submit the paper to a chemical analysis. It is not impossible that Mondrian used good quality ivory-coloured paper to begin with, with just such an effect in mind.

Next it is interesting to guess at the kind of pencil Mondrian might have used. It was probably a waterproof charcoal pencil. It is also clear that the paper was not stretched as it should have been (the way I described on pages 10-11).

In fact in the upper area of the sky you can see water rings that formed as the paper dried.

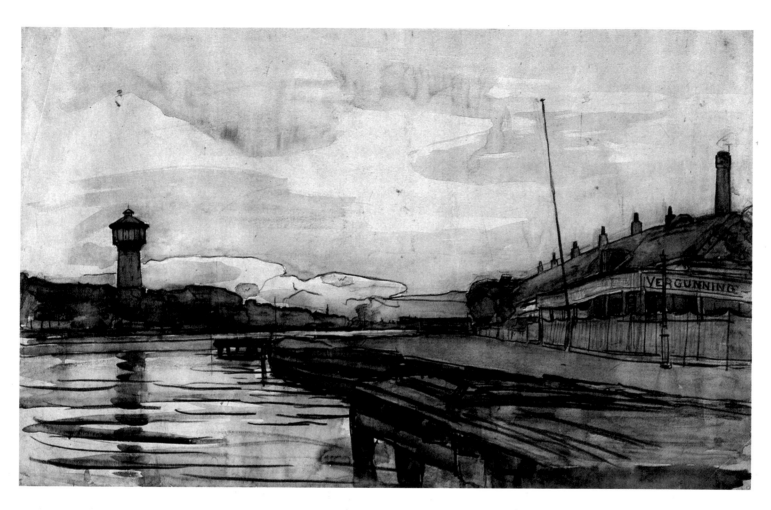

His clearly visible charcoal sketch lines create a feeling of volume without the need for much detail.

This painting reveals Mondrian's capacity for synthesis and is at the opposite end of the spectrum from the typical insecure dilettante, who, worrying that he has not done enough work, ends up putting in too much detail.

Other dilettantes make just the opposite mistake, that is, draw-ing less than is needed and then trying to make up for it by overdoing the colour.

Piet Mondrian (1872-1944) - The River Amstel.
Watercolour on paper (69 × 110 cm).
The Museum of Modern Art, bequest by
Sheidon Solow, New York.

As always, the secret lies somewhere in between and consists of drawing the essentials and then defining the volumes by categorising them as either empty or filled spaces. What do we mean in painting when we say "empty" and "filled" space? To help you understand this concept, let me give you an example: a tree is a "filled" space as is the tree next to it, while the space between them is an "empty" space.

Leaves, when seen as volume created by the foliage of the plant, are filled space, but the bits of sky that can be seen through the leaves are empty.

Another example. A shadow on the ground, in relation to the general tones of the meadow, would be considered an empty space in relation to the filled space of the meadow.

In a reflection anything that is reflected would be considered a filled space, anything that reflects would be considered empty.

Of course there are no mathematical formulas involved here. The ability to understand this concept of filled and empty spaces depends mostly on the sensibility of the artist, namely, you.

The concept of filled and empty can also be applied to colour: a warm colour is always considered a filled colour in contrast to a cool colour. But a cool colour may be considered either empty or filled, depending on its tonality.

A permanent green, for example, which is a warm green would be considered filled in relation to an emerald green, which is a cool green and thus considered an empty colour.

To accustom you to this view of painting I will give you more examples of filled and empty spaces as we look at other paintings.

Let's return now to Mondrian's watercolour and see how the painter created this very suggestive evening atmosphere. He managed it using only two cool colours, ultramarine blue and emerald green.

For the parts in deepest shadow, he worked with ultramarine blue, quickly extending the tone and diluting it by different amounts to get variations in transparency.

In this way he managed to give his colour a light transparency in spite of the uniform brushwork. It is, in fact, the different amounts of water that create the different tonal values of light

and dark as it dries. Next by adding a little emerald green to the ultramarine blue, Mondrian created the half tones that follow the upper parts of the trees on the horizon and the lighthouse tower. Using the same colour but much more diluted, he created the area in the foreground that makes up the pier and the building on the right. With the remaining colour, by adding a lot of water and ultramarine blue to it to reduce the influence of the green to a minimum and with few brush strokes, he painted in the clouds, letting their undefined shapes appear.

The reflections, achieved with only a few brush strokes, again incorporate all the colours used in the landscape.

As for the brushes Mondrian might have used, one almost certainly would have been flat-shaped for painting the vast expanses of sky and he probably used round-shaped brushes for the rest.

The size of the painting suggests that the brushes were big.

THE BRIDGES OVER LAKE BIOR

Lake Bior is a small lake, an extension of Lake Molveno in Trentino, and it is one of those peaceful places where I can paint without being disturbed. Over Lake Bior there are four bridges, three wooden ones and one made of concrete. Seen from various angles, they create interesting perspectives. You reach the first two bridges from the path that skirts the left side of the lake. Here I did my first watercolour. From the opposite side, vistas of the third and fourth bridge open up. That is where I did my second watercolour.

I worked on the first in the afternoon between two and six, on the second in the morning from nine to twelve. When you paint a landscape it is important always to work during the same hours so that you keep the same contrasts of light and shadow.

We all know that a tree may be in full sunlight in the morning but by afternoon might be completely in shadow, or with its back against the light.

I did my first watercolour on "cheap" paper (very pulpy with little cellulose), the kind sold in shops as "sketching paper", an

Ettore Maiotti - The Bridges over Lake Bior (77 × 28 cm).

ivory-coloured sheet similar, I think, to the one used by Mondrian in the watercolour "The Amstel River". For my preliminary sketch I used a charcoal pencil Fila n. 3, a fairly water-repellent pencil whose marks mix with the watercolours.

In this study geometric construction is very important. The perspective is accentuated by the structure of the wooden bridges with their small diagonal support beams. It is a very rhythmic structure with a harmonious relationship between empty and filled spaces. To give you a better idea of how I worked, I will show you the different phases of construction (see page 24).

In the first example (see page 24, above) you can see the initial lines of construction with the dimensions of the bridges in the foreground and in the background. Also in the foreground there is the suggestion of trees and on the left lines indicating the direction in which they grow.

In the second stage (see page 24, below) I began to define with more precision the relationship between filled and empty spaces, establishing the approximate distances among the different vertical posts of the railing. For example, from where I was

standing, there seemed to be more space between those closer than those at the far end of the bridge. The plane of the small footbridge inclined slightly upwards (a trick of perspective) and the support beams and the surface of the water followed the same slant.

The bridge in the background seemed to be on a flatter plane, the sense of perspective coming from the spacing of the vertical railing posts.

I drew them in sequence, beginning with those in the foreground in full sunlight, then, slightly staggered, those in the shadowy middle ground. The sense of the angle of the bridge comes from the slant of the support beams which accentuate the effects of the foreground and middle ground of the railing posts of the footbridges.

In this phase, I filled in the trees until they covered the upper half of the sheet. I then accentuated the details of the earlier drawing putting in the lights and shadows or, if you like, the filled and empty areas of foliage (see page 25).

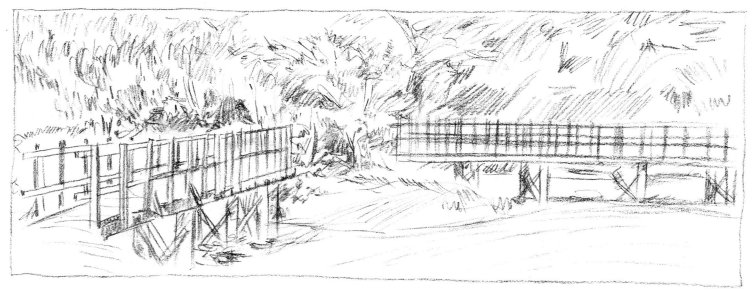

These then are the essential stages of the preliminary drawing. Of course there are other intermediate stages but there is not enough space to go into all of them here. If you use this method, however, you will find that things come naturally without your even thinking about them.

Once I finished my drawing, I set up my palette as described on page 16.

This is the palette that I have developed from thirty years of experience. I always use the same one because it suits my needs so completely.

The basic colour I started with for this work was a bistre I mixed from emerald green and carmine red. It is similar to the one I used for the sketch of the rice field.

On the right are the colours and mixtures that I used in this watercolour.

For the wooden bridge I mixed yellow ochre with a little raw umber for all the half tones; yellow ochre, raw umber and light cadmium red for the parts in full sunlight or in brighter light; raw umber and ultramarine blue for the zones in full shadow; carmine red, ultramarine blue and a little emerald green for the

support beams and violet for the plants; ultramarine blue, cadmium yellow and cerulean blue for the ferns growing between the two bridges. I got the lighter greens with a mixture of ultramarine blue, light cadmium yellow and permanent green.

The deep green was a mixture of ultramarine blue, cadmium yellow light and emerald green.

Finally for the tree trunks and branches, I used ultramarine blue and vandyke brown.

For the reflections in the water I used the same colours but added a little cerulean blue.

I painted the second view from the opposite side of the lake, working with the morning light. From my new viewpoint I could see the first little bridge, then the one in the middle (the one you see on the left of the previous watercolour) and in the foreground the concrete bridge.

The quick succession of bridges with their different angles, the study of perspective, the density of the foliage at the top on either side which borders a kind of truncated triangle formed by the bridges and the water, give this painting a special air. The sinuous form of this narrow lake that widens beyond the last bridge of Lake Molveno seems straight out of an exercise from a manual on perspective.

My day's work was thus divided into two parts. In the morning I worked on the second painting whilst in the afternoon I spent my time on the one I had begun first. Since colours in the morning are much bluer, I preferred to prepare a second palette even though logically I could have used the same one for both paintings. I did the drawing in the second painting exactly as I had done in the first, working through the same stages as I do in all my works: that is, after a general sketch to establish the volumes I begin a very broad drawing in which I start to indicate the filled spaces and the empty ones until I reach a certain harmony.

I then finish the drawing modifying the details until I achieve a fair likeness. It seems unnecessary at this stage to explain how I mixed the bistre.

We have already gone over that and I always mix it in the same way. But it does seem useful to mention the various colours that I used to get the whole chromatic range in my painting. Here is what I did.

For the darkest greens of the plants I used light cadmium yellow, ultramarine blue and emerald green. For the shadows of the leaves, ultramarine blue and burnt umber; for the violet of the leaves in the foreground, light cadmium yellow, ultramarine blue and yellow ochre.

For the railing posts of the first small bridge, it was necessary to distinguish between the parts in full sunlight and those in shadows.

For the first, yellow ochre and, in some places, yellow ochre mixed with light cadmium red. For the second, carmine red and burnt sienna.

For the base of the bridge, ultramarine blue and vandyke brown; for the violet parts, ultramarine blue and carmine red. For the pines in the distance, a very diluted ultramarine blue. For the reflections in the water to the right, light cadmium yellow, ultramarine blue and burnt sienna.

For the darker tree trunks, ultramarine blue and vandyke brown. For the posts holding up the bridge, ultramarine blue and burnt sienna for the darker parts, ultramarine blue and raw sienna for the lighter parts.

At this stage I would like to make an observation. Each time that you put two or more colours close together, it is important that there be a balance between them.

There are different ways of handling this. Some artists do it by adding a small amount of the left-over colour used previously to the new one so it is slightly influenced by it, some add a drop of its complementary colour to it, and some, like me, add a little bit of bistre. By a little I mean about 5%, with more added if necessary.

Any addition should be added gradually so the tone of colour is not lost. You can see why it is important to train your eye to evaluate small variations.

If the composition of colours ends up dominated by the tones that should balance it, it is better to throw it away and start over again rather than try to correct it.

26

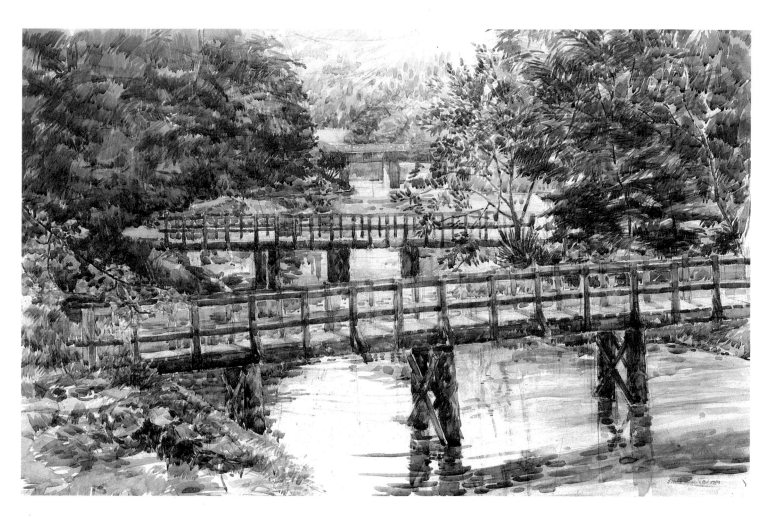

Ettore Maiotti - The Bridges over Lake Bior (96 × 61 cm).

The palette has a very limited amount of space on which to work and if you use too much paint for a mixture you will not have enough space for the other colours.

And, while we are talking about mixing colours, here is another practical suggestion.

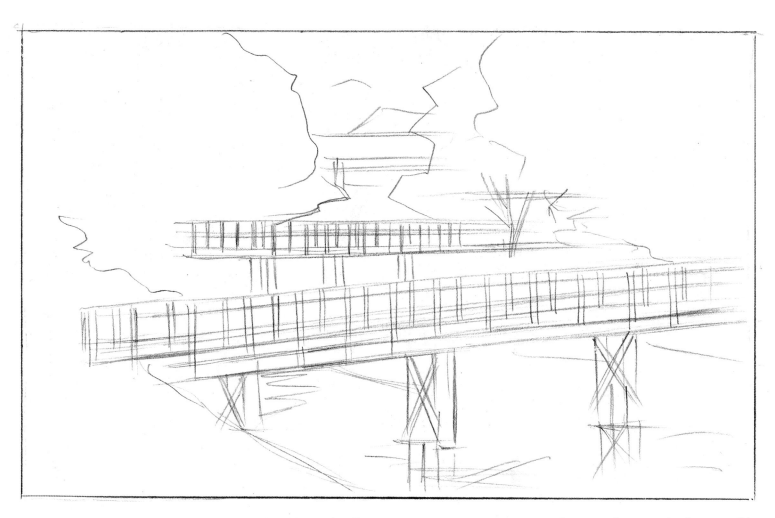

If you are trying to obtain a green by mixing blue and yellow, start with the blue and add the yellow little by little.

If you begin with the yellow, to get the green you want you must add a lot of blue and will end up with far more paint than you need on your palette.

Remember then always to begin with the darker colour and add the lighter colour to it, and not vice versa.

I begin the sketch by outlining the major shapes as simply as possible, taking into consideration the format of the sheet. I keep the lines light (so they can be erased easily) and sketch in only the essentials at this stage. It is a mistake to get bogged down in details so early on.

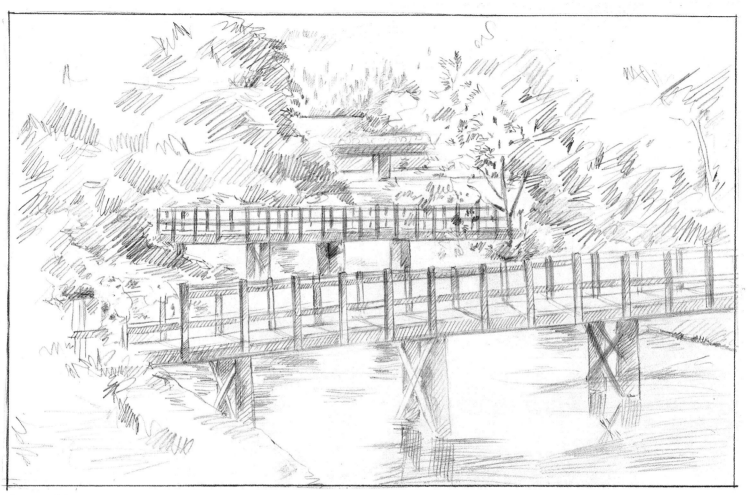

On page 28, 29 and 30 I have produced only the most important of the next phases of the three landscapes. Naturally there are other stages in between but one should move from stage to stage smoothly and fluidly, with no obvious gaps between them.

At this stage I begin to fill in the details. Here I have begun to add the shadows, both on the bridges and on the foliage.

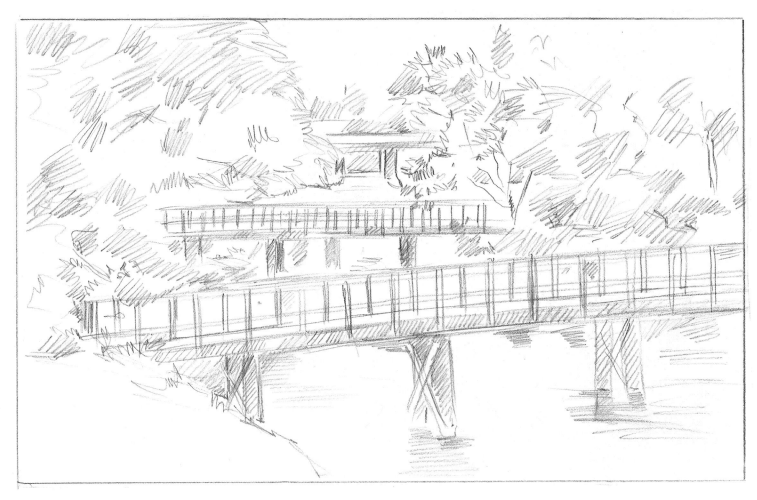

In the last phase just before beginning to paint, I finish filling in the details.

It is important to do this in stages, uniformly and consistently: the drawing should be thought of as a whole.

A beginner often makes the mistake of concentrating too much on one particular section, trying to overcome his insecurity by filling it with detail to the detriment of the whole.

Details should appear as the result of layers of superimposed volumes; they should not be parts worked on separately and brought together.

LAKE TOBLINO

Working with other painters is an important experience for those who want to learn to paint landscapes. This series of watercolours was painted by my wife, Luisella, and myself along the banks of Lake Toblino.

Before beginning our large-scale paintings, we did a series of smaller scale studies of some of the details to help us to decide which spot we thought would make the most interesting composition to paint.

To decide on a composition, that is the framing of a scene, one must go back to the discussion of "empty" and "filled" spaces: water is an empty space, land a filled one.

To achieve the effect of depth in the subject we are looking at now, we chose to give greater importance to the empty spaces, making the filled spaces recede to the middle ground. In another case one might do the opposite, giving the filled spaces more prominence so they become the foreground while the sky or the mirror-like surface of water, the empty space, moves to the middle ground.

Let's clarify this concept further. To paint a landscape in which the sky and the expanse of water are to be considered as the foreground, we calculate a ratio of three to one between empty spaces and filled ones, but use an inverse ratio if the filled spaces are in the foreground.

It is also important to get used to copying a subject under different conditions as a landscape alters noticeably with changes in the light and the weather.

Once you have learned how to create atmosphere in your painting you will know how to change it to suit your own mood.

We know that someone feeling depressed will often find comfort painting a rain-filled landscape; that someone whose soul is troubled may reflect it by painting a lake stirred by wind and storms; and a person at peace with himself will generally choose a sunny subject.

The creation of a particular mood also depends on what the painter wants to communicate. Do not forget that a painter is

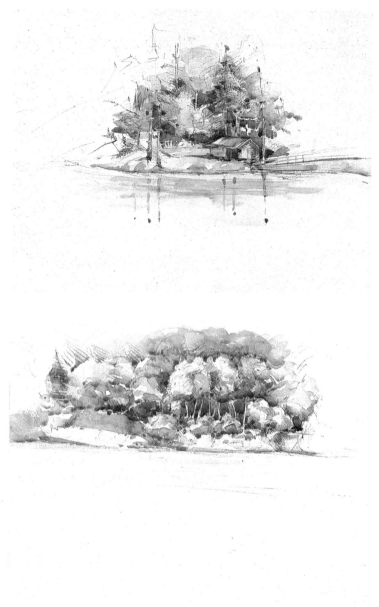

31

On the preceding page,
*a detail from Lake Toblino
by Luisella Lissoni.
Here, details of Lake Toblino
by Ettore Maiotti.*

always, in some way, autobiographical and tends to project his own feelings into the works he creates. Of course these are rather simple and obvious examples. With maturity a painter may express his tormented state even when he is painting a sun-filled scene.

Van Gogh did this so convincingly that one can feel anxiety just looking at poppies growing in a field of corn.

As you can see in the sketches here, Luisella used a colour scale based more on browns, while I preferred cooler tones.

While I continued to work on my sketches, Luisella started her large-scale work in the morning light of a warm August day, when the haze made everything look grey and misty.

Luisella began with a very broad preliminary sketch (by "broad" I mean a very general and approximate drawing meant only to lay out the composition on the paper), using a very soft B6 pencil and a light hand.

Now more advice. Knowing that light is strongest in the morning and decreases towards evening, in order to paint when the atmosphere suits you best, you must calculate how long you will have to spend on your drawing, so that you are ready with your colours at the right moment.

If you work as Luisella did you will move from a broad drawing to one that is "tightened up" (this may make more sense if you think of it as a shoe that fits best when well-laced up).

The sequence of work moves from a broad design to a gradually more detailed work, until a balance is reached between the filled and empty spaces.

The balance should be as close as possible to that of the actual subject.

The warm grey tones winding through the landscape, the mountains barely visible in the background and the castle set in the upper half of the painting, balance a broad expanse in the lower part; the water, seen through a mist, has no reflections, just a silvery colour.

To start, bistre is laid on in very diluted form, mixed with warm and cool colours in almost imperceptible amounts, so that there is only a variation of tones.

If, as Luisella has done, you keep an eye on your tonal values,

32

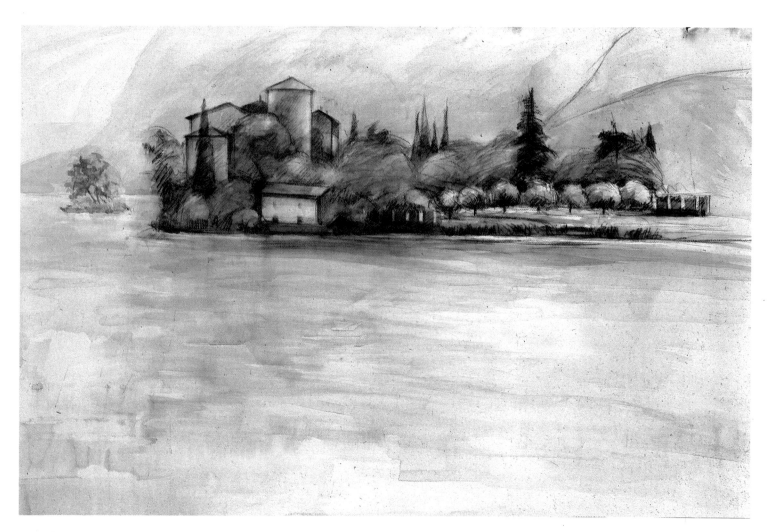

you will end up with a silvery feel that plays against the white
of the paper.
This gives the sensation of reflections.
I advise watercolourists to keep a close eye on their colours
from the point of view both of dilution and of quality (that is to
say, tone).

Luisella Lissoni
Lake Toblino (90 × 60 cm).

33

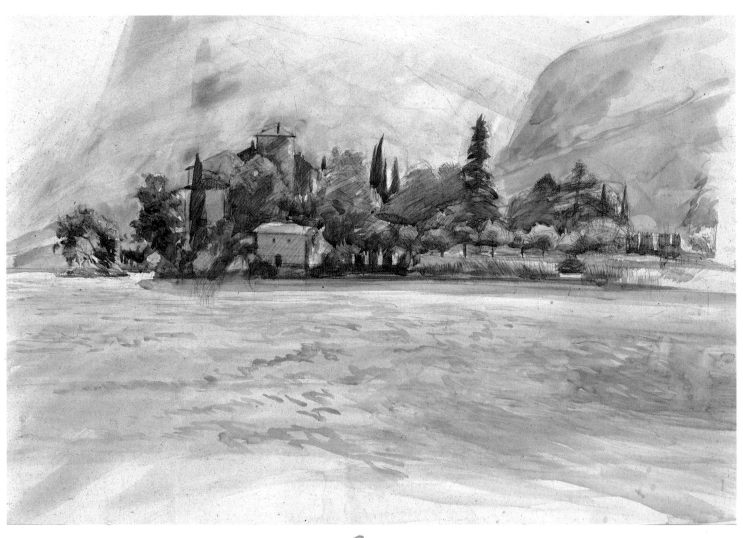

Ettore Maiotti - Lake Toblino
(90 × 60 cm).

The word "tone" has its origins in music. In painting it means the ideal juxtaposition to create a harmonious effect. When colours are not balanced, they are called, as in music, dissonant or strident and they are jarring to the eye. Musical terms are often used in painting when we want to express similar sensations.

Luisella had already worked an entire day on her watercolour when I finished my series of studies. I found a spot near her and began to draw my second watercolour.

The sun had already burned off the mist and a light breeze had started up creating irregularly shaped shadows on the waves. By then the castle and the mountain no longer cast any shadows on the water.

In the distance, because of a counter-current, the waves formed a silvery wake that washed the shores and circled around the island. Above, a light mist still softened the colours of the mountains. This is the atmosphere one finds in August between noon and three in the afternoon.

The range of colours that I used in this painting is more or less the same as I indicated in the chart. On the following days, thanks to a light breeze, the fog lifted and Luisella painted this watercolour (page 36) characterised by lovely reflections.

Following the same logic that I used for the watercolour of the rice fields, I used very diluted ultramarine blue to paint the wake created by the subterranean current. Ultramarine blue is also used in the foreground.

These are the brushes that we used

35

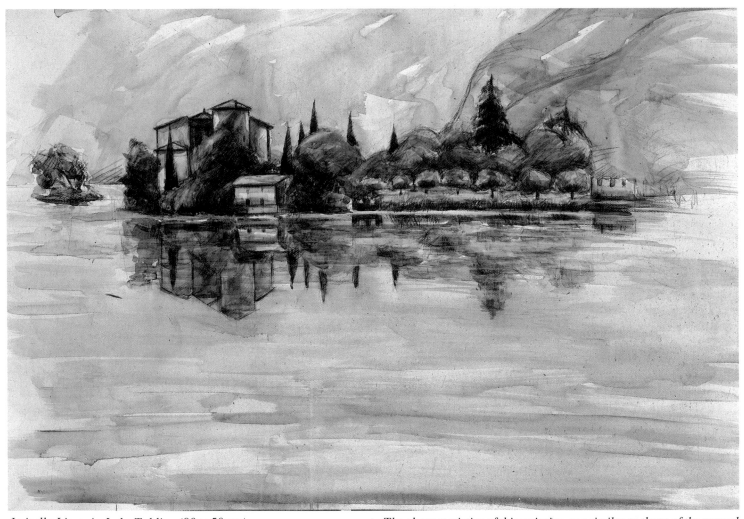

Luisella Lissoni - Lake Toblino (90 × 50 cm).

Facing page: from the promontory where the castle of Toblino sits, looking towards the west you can see the villa Luisella painted in this watercolour.

The characteristics of this painting are similar to those of the preceding watercolours, that is, the same vegetation, the same light, the same atmosphere.
The only difference is the paper used. Instead of a white Arches paper, an ivory Ingres-type paper was used. You can see how the same colours, used on an ivory-coloured sheet, have a warmer tone.

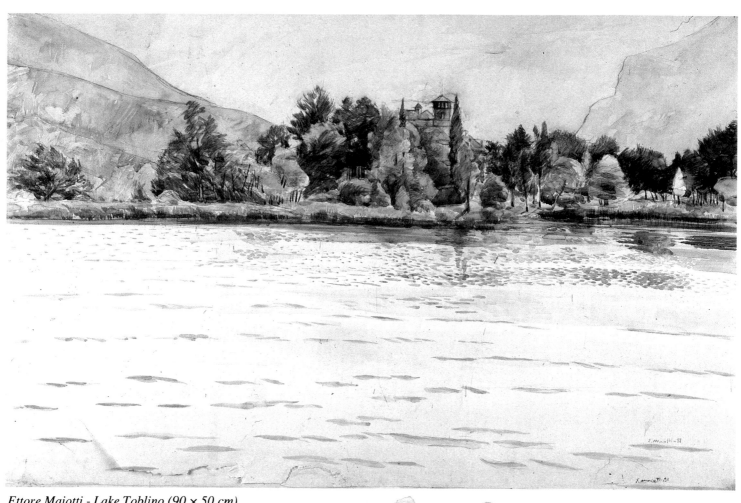

Ettore Maiotti - Lake Toblino (90 × 50 cm).

37

THE SOFT LANDSCAPES OF FELICE VALTORTA

One of the watercolourists with whom I often paint landscapes is Felice Valtorta. Felice uses a special technique, somewhat different from both mine and Luisella's. He starts with a very light single line drawing and does not use bistre to create a three-dimensional base. He begins at the top of his painting and placing tone next to tone, he washes "veils of colour" over his drawing.

He works slowly, from top to bottom and side to side, continu-ally superimposing more colour when the underlying colour is dry, thereby creating very transparent washes. Looking at his watercolours you can see they start with light tones over which dark tones are gradually superimposed.

Thus Felice manages to give his paintings a very soft feel. These three watercolours (below and on pages 40 and 41) are the result of studies done expressly for this book.

Felice Valtorta - The Old Landing (60 × 35 cm).

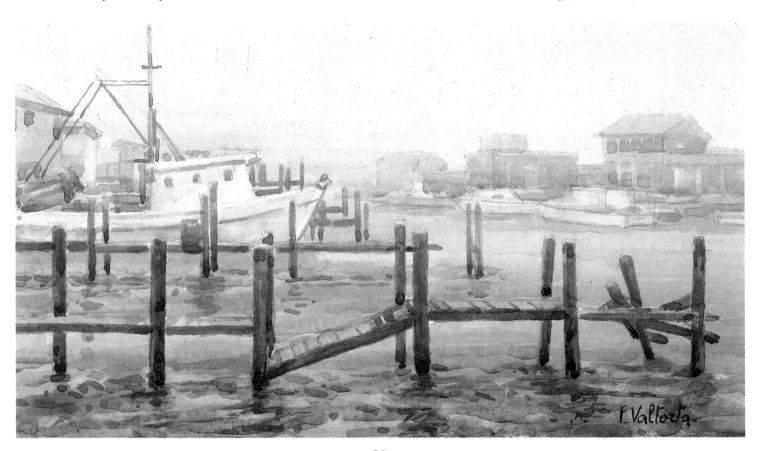

38

The Old Landing

In the small seaports still used by fishermen today, old structures often lie side by side with more recent constructions. Felice likes the contrast of these scenes where the past seems to be making a last gasp attempt to assert itself before it disappears altogether.

For this watercolour (on page 38) he used the following colours.

For the upper part of the sky, cobalt blue and a little rose madder fading towards the horizon.

For the houses, cobalt blue and venetian red repeated in the darkest parts.

For the sea, the base tones are cobalt blue, a little indigo and a little raw sienna.

The halftones are indigo mixed with a little cobalt and rose madder deep. The dark reflections are indigo.

For the wooden gangways, Felice mixed burnt sienna and cobalt blue.

For the support posts, indigo mixed with a little vandyke brown and carmine red.

For the motorboat, cerulean blue and a very little bit of rose madder.

The white areas come from the white of the paper left untouched.

Urio on Lake Como

Lake Como is a favourite subject for Lombard watercolourists. It is common to find painters along its banks painting the old churches reflected in the water and the characteristic-coloured Lombardian houses. In this watercolour (on page 40) Felice used the following colours.

For the sky, he again used cobalt blue mixed with a little rose madder and a drop of venetian red faded out towards the horizon.

For the mountain in the background, he used the same colours as for the sky but with a little indigo added to them.

For the mountain in the middle ground, he used the sky colours mixed with a little ultramarine and a drop of yellow ochre.

For the vegetation, ultramarine, vandyke brown and a drop of indian yellow. (For the vegetation in the foreground, a little burnt sienna was substituted for the vandyke brown).

For the houses in full sunlight, a wash of cerulean blue and a little yellow ochre and for the areas in shadow, cerulean blue, a little yellow ochre and a drop of cobalt blue and venetian red.

The roofs of the houses are a mixture of burnt umber and a drop of burnt sienna.

For the tones at the base of the lake, he mixed cobalt blue and a little yellow ochre strengthened in the foreground with ultramarine.

The same colours were used for the darkest reflections, with a little indigo added.

The tones of the wooden piles were obtained by mixing vandyke brown and a little carmine red darkened with traces of ultramarine.

In this painting, the paper was also left white for the areas in full light.

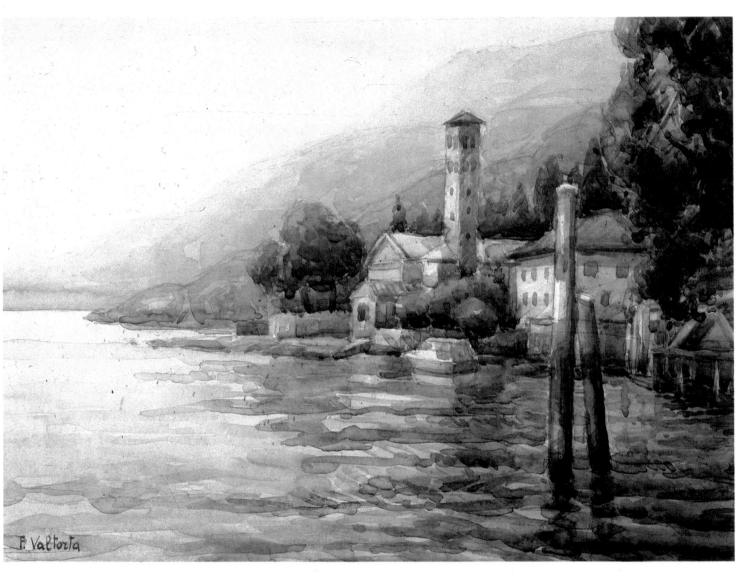

Felice Valtorta
Lake Como (50 × 35 cm).

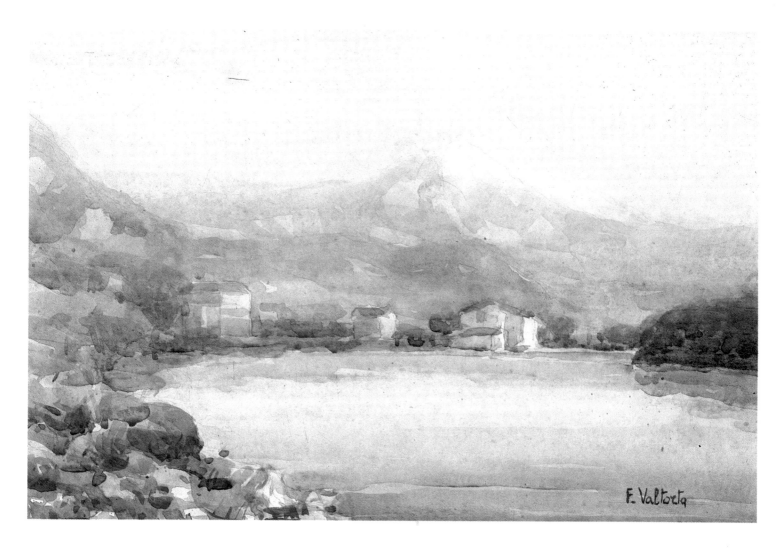

Felice Valtorta - Along the Adda (60 × 35 cm).

Along the Adda

Let's look at one more of Felice Valtorta's watercolours, one done along the banks of the Adda.

In this painting too the colours are tones of blues and violets alternating with "warm" areas according to a precise logic. Notice, for example, how the lower left-hand area is counterbalanced by the same tones in the upper right of the painting where

41

the sunlight falls on the mountains, but it is made more transparent by the use of a small amount of blue. To copy this watercolour you should use the following colours.

For the sky, cobalt blue mixed with a little yellow ochre and a touch of rose madder.

For the mountains, the effect of sunlight on the peak was obtained by leaving the paper white, while the warm zones of the peak just below were made with cobalt blue mixed with yellow ochre and a little venetian red.

For the tones of the mountain in general, he used indigo blue, a little yellow ochre and venetian red mixed with a little cobalt blue and, for the darkest parts, different mixtures of the same colours.

For the houses, burnt umber and a little cobalt blue, made more intense in the darker areas and more transparent in the lighter zones.

For the banks of the river, yellow ochre, pale cadmium red and a little cerulean blue with a little indigo added in varying amounts for the darkest areas.

For the water he used cobalt blue and raw sienna in the lightest part and added indigo and a little dark rose madder for the darkest areas.

The reflections in the water were achieved with a mixture of cobalt blue and a little dark rose madder, while for the darkest areas he added some indigo.

THE WHARF

If you come upon a picturesque spot, get it down on paper as fast as you can.

You may not have another chance. A few months ago I found myself on the banks of a lake from which I could see a row of boats and a long wall of concrete on which the water reflected a particular grey blue light.

I did not have any watercolour paper with me but the desire to paint was so strong that nothing could stop me. In a local country store I found some sheets of white packaging paper that I could adapt to my purpose.

I knew that the dock had been made of wood that was over a hundred years old and now the old wood was being slowly replaced with new.

I was afraid that soon it would all disappear, to be replaced by something completely new, functional perhaps but not as romantic or fascinating, and I felt the urge to finish this painting quickly.

Town and country architects destroy with the speed of light what was built so masterfully by carpenters of the past. It's here today and gone tomorrow.

So if you come across something like this, copy it immediately. It may disappear off the face of the earth before you have time to blink an eye.

The paper I managed to find was cheap paper with a lot of wood pulp and not much rag content, which tends to yellow with age.

But its white or cream colour does not affect the harmony of the painting as long as the chromatic values are balanced.

If you want to try painting on paper like this, prepare your paper using the method I explained earlier. (I hope by now you are putting into practice what I have told you.)

I suggest you use the rough side of the paper and do your drawing with a very soft pencil, a Contè crayon, or even a sanguine or red pencil.

Back at the wharf, I was struck by the anchored boats, all the

the same colour, and by the colour of the water. In that spot the Messò River flows down from Lake Molveno and the currents, coming together there, create green and blue effects which are reflected on the walls of the concrete, giving it a marbled look.

When you have the chance to copy boats, keep one thing in mind: even if only imperceptibly, boats are constantly in motion, bobbing up and down and back and forth.

When they are tied or anchored, their movement becomes almost circular.

So, when you start to work, pick a reference point, a branch, for

The colours I used

example, or a trunk that coincides with the edge of a boat, or the distance, say, between an oar and the boat.

Copy as much as you can before the boat is carried by the current and moves.

Then wait until it gets back to the same spot.

In the meantime put in all the non-moving elements around it.

To render the effect of water in movement, you must simply rely a bit on your own instincts.

Look at the form of the lightest reflection, fix it in your mind closing your eyes for a moment, then sketch it with your pencil and check it against what you see in the water a moment later.

The brushes I used

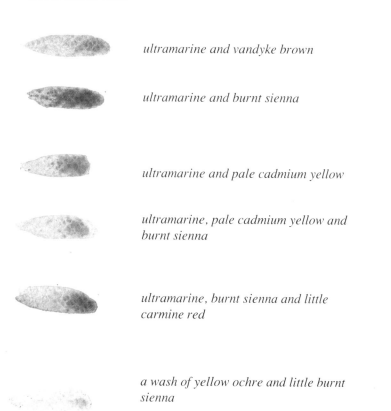

ultramarine and vandyke brown

ultramarine and burnt sienna

ultramarine and pale cadmium yellow

ultramarine, pale cadmium yellow and burnt sienna

ultramarine, burnt sienna and little carmine red

a wash of yellow ochre and little burnt sienna

43

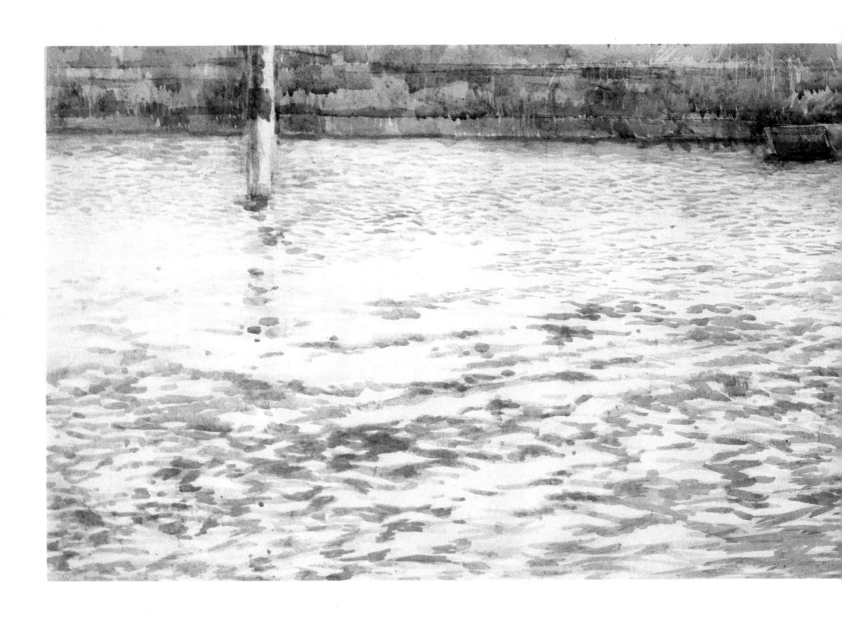

Ettore Maiotti - The Wharf (100 × 25 cm).

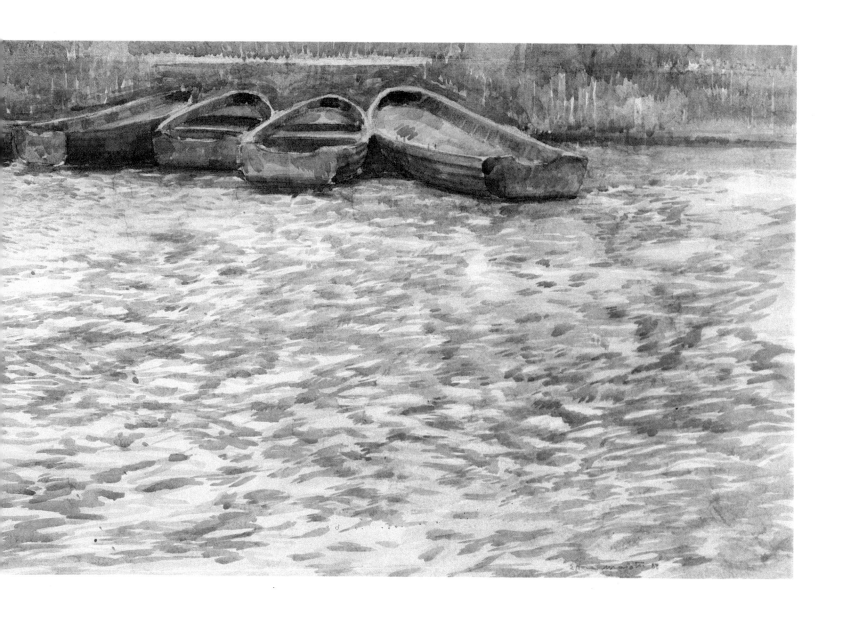

45

EMIL NOLDE
AND THE EXPRESSIONIST WATERCOLOURS

A watercolour by an Expressionist painter is painted using a completely different method from those we have seen up till now.

First of all, the paper of the Expressionist watercolourist is not always stretched. On the contrary. If it is not stretched, when it is wet it curls up and forms little pools of colour which a good watercolourist will know how to use to good effect.

A second difference regards the "supports" used for painting. The Expressionists were very casual about what they used, in the sense that they would paint on just about anything that happened to be within reach.

If you would like to try to paint in the Expressionist style, start with whatever paper you have handy and work on a small scale using a big brush, possibly of squirrel's hair, as you would for an oil painting.

This time you should work sitting down, on a flat surface, just the opposite of what I have told you so far.

But remember: in painting, there are no absolute rules, only some basic techniques which will get you from zero to your first results. After that, each painter must apply them in his own way, following his own instincts and artistic sensibilities.

Let's look now at what you can achieve working with this technique and the different results you will get using two different kinds of paper, one, for example, a Moulin du roi type paper and the other an ordinary ivory-coloured sheet. We will use the same technique with both.

First of all, wet the paper with lots of watery brush strokes and let the paper absorb the water for about a minute. Then (with the idea of painting a sky similar to the one in Nolde's watercolour

reproduced on page 48) mix some yellow ochre with a little cadmium orange, heavily diluting the colour and, with a wide brush, wash on the base colour.

As it dries, the paint on each sheet will form rings of colour here and there.

So even if we wet the paper again in exactly the same way and paint it with the same density of colour, we will always get different results.

We can also vary the results by using different kinds of paper. If you let the paper dry now and, using the same technique, apply other colours over the first, you will get new rippled effects. When you finish this wash, let the sheets dry and then, using bistre or indigo or vandyke brown, outline the subject that you sketched in at the beginning with a pencil.

The first time you try this technique you may have disappointing results (it happens to everyone), but do not give up.

Experiment again and again, learn to control the amount of water you use (it should always be quite a lot), take care that the colour is very wet and transparent on the paper and that it does not clump on the brush (clots of colour in a watercolour painting should be avoided at all costs).

As opposed to other painting techniques, in a watercolour or fresco painting well-diluted colour is very important for the best results.

When you have learned to control the balance of water and colour, you can also control your "blotches". Do this by first wetting the paper, then extending the colour, deepening it if necessary by letting a few drops fall from the brush onto the colour that has already been laid down (as long as the colour is wet you can modify it, adding other colours, drop by drop, for a variety of effects).

But be careful. If there are too many colours on your paper and

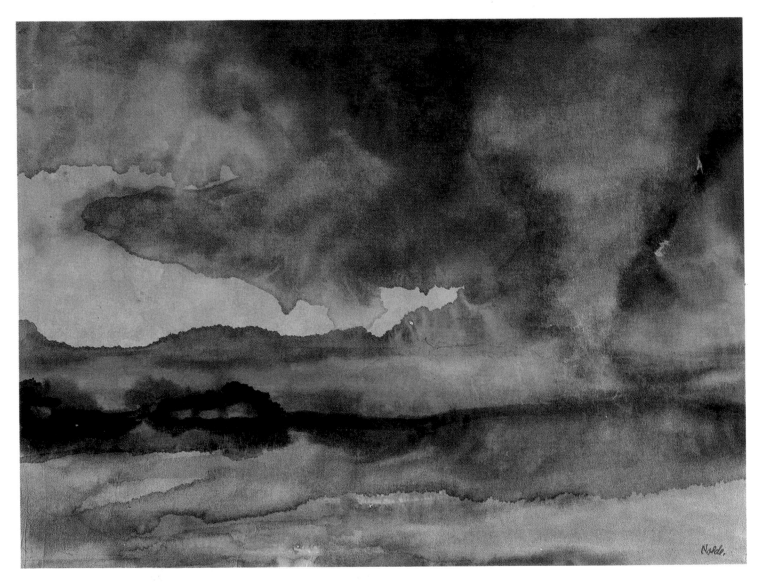

Emil Nolde (1867-1956) - The Flood.
Watercolour on paper (35 × 47 cm). Seebüll, Nolde Stiftung.

paper. Now wet the paper in water and, keeping the rough side of the paper (the side you will use for painting) away from you,

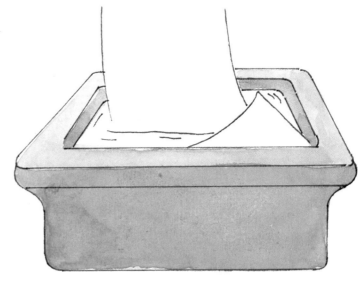

too much water, do not try to absorb it with paper towel or a sponge. The tip of the brush works better. Just squeeze out the water from it first.

Once you have learned to paint with more confidence and are no longer afraid of "ruining" your work, you will be able to manipulate your blotches the way you want.

This technique can also be used on a support stretched over wood; one which will be very strong even if you are using lightweight paper.

To prepare such a support, you must first get hold of a small plywood board about 5 mm thick and slightly bigger than your

spread some glue, made with two parts of vinyl-based glue and three parts of water, over the reverse side with a wide, flat squirrel's hair brush.

After you have done this, place the glued side onto the surface

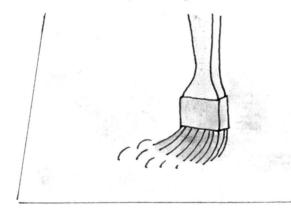

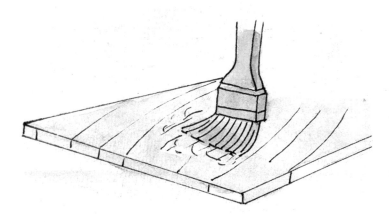

paper to the backside of the wood. This serves to keep the board from buckling as the paper dries and is stretched.

Although it is lightweight the paper stretches as it dries with a

of the plywood and then, using the same system again (with a mixture of glue and water), attach a sheet of brown wrapping

force that can make even plywood buckle. A sheet of paper glued to the back of the board can counterbalance this tension. You are now ready to paint on your support using the technique

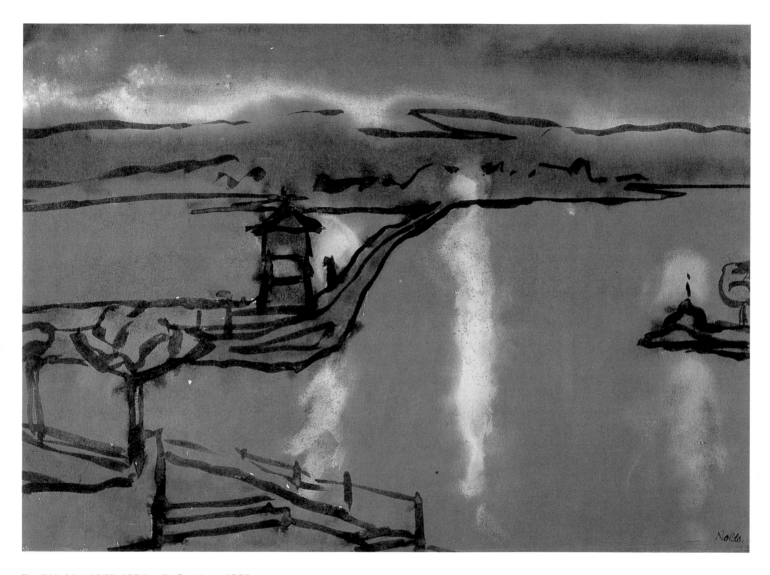

Emil Nolde (1867-1956) - Reflections 1935.
Watercolour, brush and black ink on paper (34 × 47 cm).
The Detroit Institute of Arts, gift of Robert H. Tammahill, Detroit.

described above. Keep in mind though that the board is not "recyclable".

Once attached you cannot remove it. It forms an integral part of the painting which becomes a very solid structure, with no risk of the paper tearing.

In the Expressionist painting, as in paintings from any of the movements of the past, nothing is casual.

Look at the colours in Nolde's paintings (pages 48 and 51) and, after following my instructions, compare them to your own attempts.

Notice how the dripped blotches and rings were planned and carefully controlled and how there is absolutely nothing chosen at random, not even the subject, without long and attentive observation first.

Most contemporary watercolourists who use this technique do their sketches directly with the brush and then colour them afterwards.

The Expressionists, on the other hand, often used a charcoal pencil to make a basic sketch first which virtually disappeared when in contact with water, unless of course it had been sprayed with a fixative.

After several washes of colour the light traces of the remaining charcoal were gone over with a brush and either diluted ink, bistre or black paint.

You can get the same effects as the Expressionist watercolourists by using the new waterproof pencils sold today in stores. It is rather pleasant to work with these pencils but you do need to pay attention to the darkness of the lines left on the paper. The black pencil, in fact, if it is too heavy, can end up affecting the other colours, making them too dark.

When you have learned to use them, you can take advantage of their qualities to create a darker or lighter atmosphere with a single colour, modifying in various ways the intensity of the design.

Keep in mind, however, that Expressionist painting is not just the result of specific techniques used with certain materials, colours and brushes. It expresses a way of life and of thinking,

a true and individual philosophy of existence. The colours used by the Expressionists were always connected to the dominant cool chromatic scale or rather dark tones.

The lively effect of this type of painting, from a technical point of view, comes from the unpredictable blotches of primary colours, so that between washes of orangey-ochres, raw umbers and black, a vermillion suddenly appears.

For example, look at the first painting reproduced on page 48 (*Flood*) where three red houses jump out of a cloudburst.

On the other hand, the painting on page 51 (*Reflections*) makes one think of a sunrise seen by someone who has spent a sleepless night and is still awake to see the long reflections formed on the water by the last light of the street lamps. This watercolour was done with brush and ink.

Keep in mind that only through sound technical training will you be able to express your emotions and state of mind with any depth. Without technical expertise you will never be able to express what you feel inside.

ENTRANCE TO THE PORT BY LYONEL FEININGER

Feininger, in common with Edward Hopper and Franz Kline, was an American painter who studied in Europe and afterwards took the ideas of the European avant-garde movement with him back to America, thus starting the American school of the 50's that would revolutionise our attitudes towards painting.

Feininger, an illustrator, caricaturist and cartoonist, was a multi-form painter, similar in some ways to the great Daumier. He was one of the founders of the Bauhaus and closely linked to Paul Klee through an affinity of thought: they were both passionate about music.

Much more figurative than Klee, Feininger carried out a subtle study of materials in preparation for his paintings. The watercolour reproduced on page 53 was achieved with a technique similar to Klee's and it is evident that the two were in tune in their thinking, consulting each other and exchanging information.

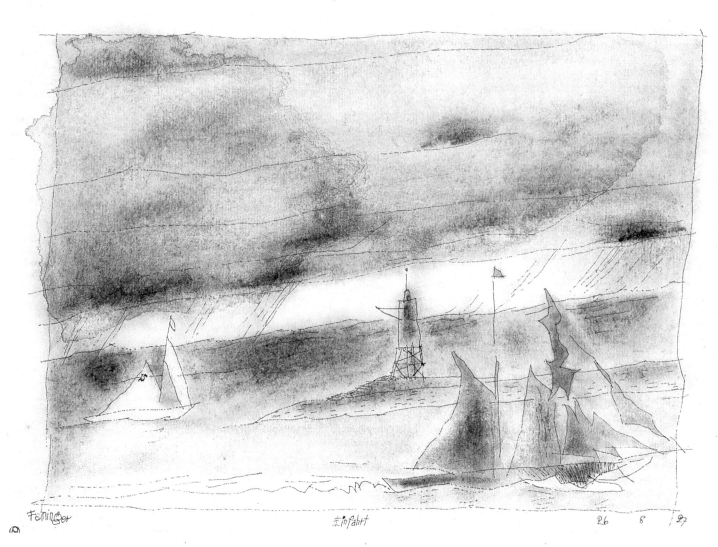

Lyonel Feininger (1871-1956) - Entrance to the Port, Stuttgart, 1927.
Pen and watercolour on paper (30 × 59 cm).
Graphische Sammlung, Staatsgalerie Stuttgart.

Feininger probably first sketched an idea in a notebook with a pencil, an image which he then with simple pencil lines redrew on a sheet of watercolour paper prepared according to the system I explained to you above, using instead of glue, a kind of paper once used for wrapping packages, that came coated with a layer of glue on one side. Today it has been replaced by plain paper and adhesive tape, which we cannot use for this purpose.

In this watercolour, Feininger, after doing a preliminary pencil sketch, went over the lines with pen and ink.

If you try this technique, do not use a rapidograph: it is an instrument best suited to technical drawing.

Painters use pens with nibs. The kind that I would recommend are those specifically made for use with India ink, such as the English brand Perry.

After tracing the drawing with ink, Feininger erased the pencil lines and then began working with the blues. The colour of the sea was probably a prussian blue (light sensitive, it tends to vanish after a few years).

Where the prussian blue is darkest, a little raw umber was added.

Using this colour he painted the sky which, as I have already explained, is always reflected in the water.

This means that if the sky is a lead colour, the water must also have this tonality.

In the watercolour we are looking at, the sky was painted with three successive washes, with a very little bit of vandyke brown added to the raw umber to warm it up.

The painter did his first wash over the whole surface of the sky; then once it was dry, he did a second wash over a smaller area.

After it had dried (note the rings that formed as it dried), he applied a third wash that you can see in the left part of the clouds in a grading of rings of colour.

You can get the same kind of effect by letting a colour dry near a heat source - which in Feininger's day might have been a wood stove or fireplace.

The artist's ability is revealed especially in his diluting of colours to achieve greater transparency and then in bringing them near, or keeping them away from, the source of heat so he could strictly control the way in which they dried and thus the effect drying had on them.

To give volume to a mass that is otherwise flat, Feininger added drops of slightly denser colours by tapping the paper lightly with the tip of his brush.

When you try this technique, you may find your first attempts unsatisfactory.

But you should keep on trying, experimenting with different paper and intensity of colours.

THE BOAT BY LUISELLA LISSONI

Here we have a watercolour on a grand scale, about 100×70 cm, which reproduces an immense landscape in an atmosphere made magical by a light fog, so frequent in autumn along the banks of the Po. In the bends of large rivers an extraordinary atmosphere is created that, depending on the season, has its own special characteristics.

In summer the dense foliage creates an intense rich green while in autumn an ochre colour predominates as the trunks of the trees appear and disappear in the fog like characters in play. In this softened atmosphere, the tree trunks seem made of frosted glass.

To paint this watercolour, Luisella used a frame with some coarse-grained Arches watercolour paper. Before beginning to paint she first wet the part she was going to paint with her brush and then mixed her paint with plenty of water to make it transparent.

This last is a very important operation because if watercolours are too dense they end up resembling tempera and lose their special value.

A good watercolourist knows that the real secret of this technique is in the perfect diluting of colour.

Blotches and rings, wisely applied, can add interest to your painting and the method I recommend (that of working standing

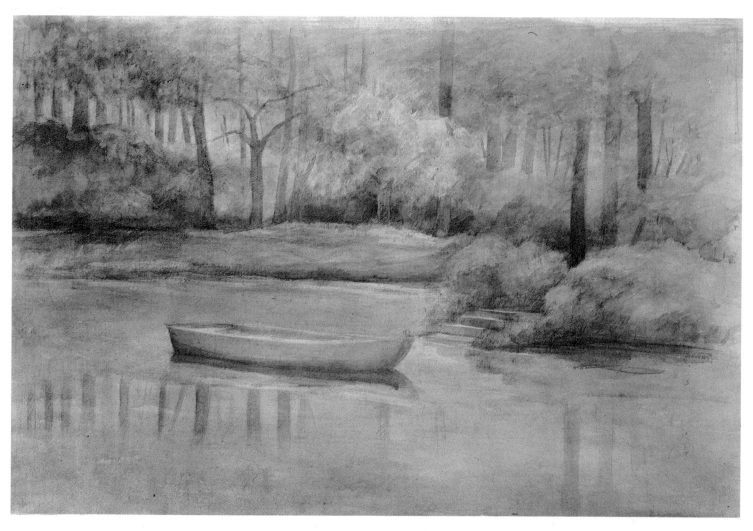

up in front of an easel) will allow you to mix the right amounts of water and colour more easily.

Working standing up, you can use either of two different methods. One demands the use of semi-rough grain paper, used dry, with a brush dipped in water.

Luisella Lissoni - The Boat (100 × 70 cm).

Wash a very transparent bistre over the areas in shadow while working on the rest of the painting at the same time. After this step

55

the result of the rough sketch should be very similar to a pencil drawing.

The other method requires the use of rough surfaced paper. To try this one, you will need two glasses of water, one to wet the brush and the other to wet the paper. Then, proceed as follows. First draw your subject with a soft sharp pencil (the coarser the paper the softer the pencil. On hammered paper for instance you should use a 6B).

The lines left by the pencil should be barely visible so work with a light touch.

A heavy line is a sign of inexperience and shows a lack of confidence.

After you have finished your drawing, take a brush full of clean water and first wet the surface that you want to colour, then mix your colours together to get the tones you want. This done, go over the paper with big washes of colour where you have wet the paper, keeping in mind that the colour should always be very dilute and transparent.

When you have acquired a certain confidence in painting watercolours, you can use this technique on any kind of paper.

Of course, it takes time to become a master of your metier.

The important thing is not to be discouraged by your first attempts.

One last bit of advice. On rough or hammered paper, you can also apply "washing technique".

What does this technique consist of? Begin by painting the way you want, let your painting dry, and then dip it in a basin full of water.

Then turn on the tap letting the water run over it to create the effect of running water.

In this way the watercolour will be lightened in a uniform way and will take on a very soft tone.

Let it dry and then repeat the operation again several more times until the painting takes on an unfinished look.

Of course you must not overdo this washing or you run the risk of the watercolour becoming opaque.

That this is another technique you will master only after making many mistakes. This is the way it always is. But in fact the more mistakes you make, the greater your success will be eventually. The important thing is not to become discouraged and carry on with confidence until you finally begin to get good results.

I have made many errors myself, so many in fact that I do not know why I did not give up. But let's return to Luisella's watercolour.

After having carefully made her drawing with a 3B pencil (and not overdoing it), Luisella wet the surface she was going to paint and then brushed in the darkest shadows with a blue-toned bistre.

The shadows reflected in the water were also done with bistre but in a slightly lighter shade than the subject reflected.

There are various reflections in the water and, as is common in marshes or on still waters, bits of debris carried by the wind and light breezes or small patches of fog ruffle the mirror-like surface of the water.

And as you can see, the trees are also reflected in the foreground of the painting.

Below Luisella shows you what colours she used and the sequence she followed in laying them down.

THE LAKES OF BRIANZA
BY CARLA MAZZOTTI

Carla's watercolours were made, as they usually are among the group of painters who work with me, on paper stretched over a frame, a Montval type paper available in art supply stores. It comes in a very practical album of sheets pre-coated with glue on one side, made especially for studies or landscape sketches.

The trick is not to detach the sheet from the album before the watercolour is dry. If you do and the paper dries before you can stretch it, it will curl up.

Carla is a one-go painter who works in a single burst of creativity. She works very fast, following her instincts and this way achieves a luminosity and a freshness that is hard to match in more methodical painters.

Thinking of Carla, one of the first bits of advice I give to would-be watercolourists is to try to capture this freshness. Make your colours "sing", and do not allow your paintings to become boring. It is not hard to get good results. You need only learn to keep the colours on your palette under control and always work on a white palette, preferably ceramic.

Carla Mazzotti - Lake Annone (30 × 15 cm).

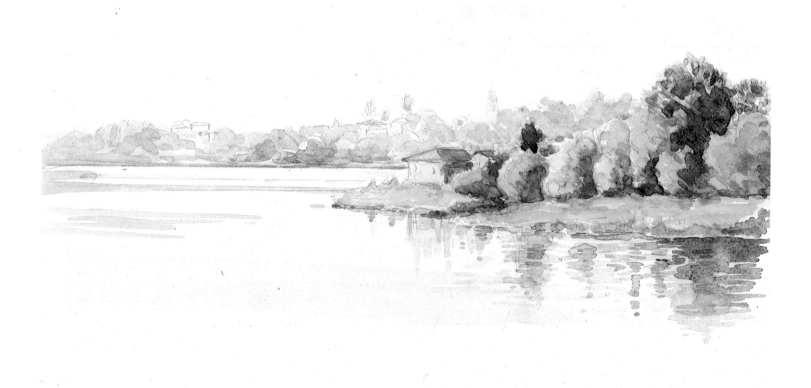

Lake Annone

In Carla's first watercolour, on page 57, you can see the tonal separation between the warm greens of the foreground and the blue-green tones of the vegetation in the background.
With the same colour, heavily diluted, Carla painted the sky.

The colour tones of the reflections in the water were identical to those of the sky and intensified by a wash of bluish bistre. On the bottom right, to accentuate the reflections of the trees in the wind-rippled water, Carla used short brush strokes, creating

Carla Mazzotti - Lake Segrino (50 × 35 cm).

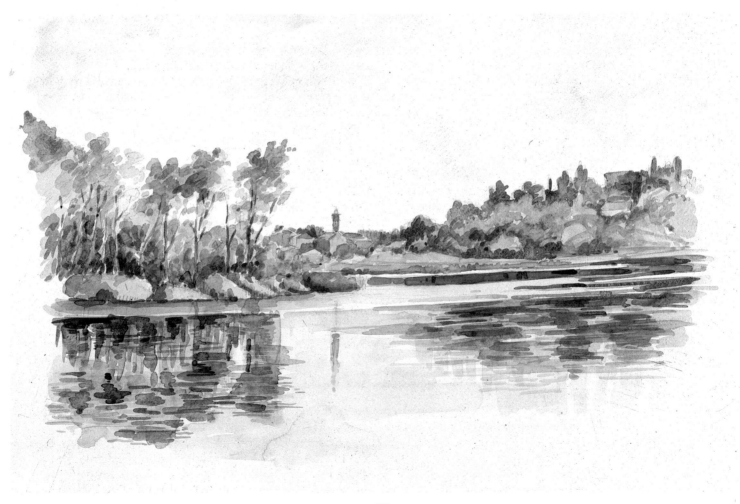

58

with skillful brushwork the impression of moving water. In the foreground a rosy tone gives the effect of depth.

If this colour were left out, the sense of perspective would be very attenuated.

Lake Segrino

Let's look now at Carla's second watercolour of a small lake in upper Brianza, immersed in an intense green typical of the Lombard landscape, with the red of the bricks and the yellow ochre of the plaster of the old houses acting almost as complementary colours.

The control of colour is another important thing for beginners to learn.

Accustom yourself to "seeing" the colour you have mixed on your palette before putting it on your sheet of paper and always have ready a bit of bistre to tone down colours that come out too bright. In fact you need add only a small amount of bistre to a green which has turned too yellow to take it back to the right shade.

Look, for example, at how well-balanced the relationship of colours is between the houses of the little village on the horizon and the woods on the right and how, on the extreme right, there are some houses so completely in shadow that they are almost a part of the shadows of the landscape.

To render the reflections on the right of the watercolour, Carla followed a technique adopted by many painters when doing sketches in their travel notebooks and which often appears in Delacroix's watercolour sketches.

This technique is based on an apparently simple operation but it is one which only an expert watercolourist can do well: by mixing the colours of the subject reflected in the water, you get a tonal value similar in effect to the kind you would get by doing several separate colour washes.

The viewer's eye will then mix together the colours to create the desired effect.

In the watercolour we are looking at, the tones of the reflections in the water in the foreground at the left were obtained by mixing the colours directly on the palette, but they are the same as that of the vegetation, which was achieved through separate washes of individual colours.

Between the first and second planes, the band of light comes from the white of the paper over which was brushed a very light wash of colour in the same shade as the sky. As you can see this is a very simple technique, as simple as a watercolour should be, compared to other techniques.

This of course does not mean that it is easy to arrive at the essentials. You need time and experience.

The real secret is to paint as much as you can, every day, even if it is only for an hour or so, but you must be consistent. You must never stop.

To stop means to start over again each time from the beginning, just as in the study of a musical instrument.

Carla's watercolours demonstrate the importance of experience. They were painted in full sunlight when the relationship between full and empty spaces is most difficult to catch. Only through constant and careful work has the painter been able to achieve the results we have been looking at.

PAINTING IN STRONG SUNLIGHT

To paint a watercolour when the sun is shining brightly is very tiring, especially in summer. Anyone attempting it should come prepared with something to protect himself from the sun and a very willing spirit.

First of all, a good hat with a sun visor is very useful (never sunglasses), because the reflections of the sun on white paper strongly influence the perception of colours.

To capture the effect of sunlight, think of an over-exposed photo.

The eye will adapt itself to the light conditions but this will not work to the benefit of the colours on your palette.

Therefore you should get used to closing your eyes for a few moments before mixing the colours on your palette: this is the

only way you can see the tones that you are preparing correctly. To paint watercolours in full sunlight is a little like painting a fresco. The chromatic results are only visible afterwards. But let's look at this work in detail. As always the drawing is very important.

Ettore Maiotti - Lake Molveno (100 × 70 cm).

It should be made with a very soft pencil (I used a 4B), sharpened to a fine point and used with a very light hand.

Do not ever try to get around this by using a hard pencil. You will only damage the paper.

The colours will collect in the lines carved by the pencil and as the paper dries the lines will be accentuated and become very obvious.

To avoid this, it is better to learn to work with a light touch.

I painted this watercolour (on page 60) with my old favourite, white packaging paper. After studying my subject carefully and at length, I decided on ultramarine with a bit of emerald green.

With this colour, diluted and transparent enough so that I could see the lines of my drawing through it, I filled in all the areas in shadow.

I gave the deepest colour to the area on the left where there are the darkest zones and over the rest of the painting I diluted my colours heavily to get very light washes.

I rendered the darkest mass of vegetation behind the house by adding a little terre vert to the mixture of ultramarine and emerald green while I got the yellowish greens by mixing a little ultramarine with yellow ochre. This colour is reflected just under the house where, to render the colours of the dolomite rocks, I used red ochre.

The reflections in the water are scarcely visible and the entire lake was done with a light wash of ultramarine mixed with a little cerulean blue and accentuated with a few strokes where the water ripples.

Using these colours I gave a silvery tone to the lake.

CEZANNE
THE BANKS OF A RIVER - Two studies

Sooner or later, anyone studying watercolours ends up standing open-mouthed in front of a painting by Cézanne.

Yet students new to painting are often perplexed when faced with a work by Cézanne. Beginners are usually perfectionists when it comes to the work of others but very tolerant with themselves. People without much experience or who learn on their own without a teacher to discipline them, develop a particular form of narcissism that makes the end results seem within easy reach. But little by little as they grow and develop their craft they start to realise that the finish line – if there is one – is still a long way off. The explanation is simple: as you study a painter, especially one of the old masters, you discover that if you have worked two hours, they have worked ten, if you have studied a subject two or three times, they have made dozens of studies, taken notes, worked out tones, and varied the light. And we are not even mentioning the material side of their existence, only the spiritual side.

To understand this better, read *Siddharta* by Herman Hesse. It may help you understand the difference between "appearing to be" and "being". The main ambition of a dilettante is a typically immature one of "appearing to be", while the aim in life for someone who chooses to paint seriously will of course be that of "being".

When you have moved from one to the other of these two visions of life, you will realise what a great artist Cézanne was, one who by the end of his life had laid down the foundations for all the movements that followed him.

The great passion I feel for Cézanne has driven me to "read" him in a very profound way. His vision of painting went far beyond that of his contemporaries.

Initially a rather mediocre dilettante more interested in a bohemian life style than in drawing, at the age of around forty he met Pissarro and woke up artistically, beginning, when no longer very young, to work incredibly hard and make up for lost years.

Cézanne started many landscapes out-of-doors which he later finished in his studio.

Others – and watercolours were certainly among these, given their size – he did completely out-of-doors.

This is the case of the two watercolours on pages 62 and 63. I will try to describe how he did them using my intuition and also by looking at the juxtaposition of colours which were washed over a masterly drawing.

Paul Cézanne - The Banks of a River (Bords d' une rivière), 1879-1881 (48.5 × 32 cm).

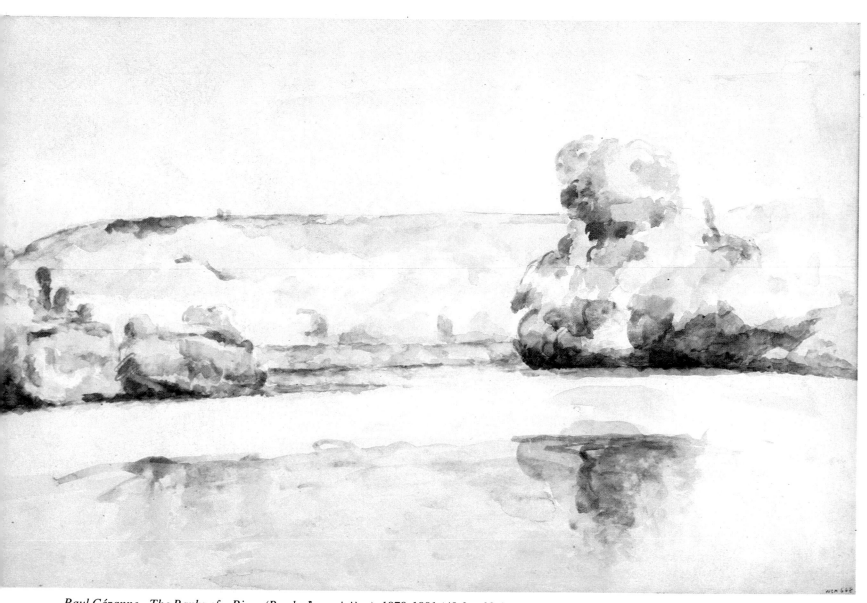

Paul Cézanne - The Banks of a River (Bords d'une rivière), 1879-1881 (49.3 × 32.1 cm).

63

With Cézanne, the basic drawing is fundamental, nothing is left to chance.

The casual look of his drawings is actually the result of almost mathematical calculations.

Let's try to understand then from the first study how Cézanne might have proceeded with these watercolours. A very diluted ultramarine is the base colour which, laid down over the darkest parts, immediately creates volume. Over this base, the artist began to work with green which, being very transparent, hardly affected the white of the paper.

In the second more finished watercolour, the greens, yellow ochres and ultramarines were superimposed on the base, tone over tone, using the technique of "wet over dry".

Then with a little indigo that can be deepened by adding ultramarine mixed with vandyke brown, Cézanne went back over the dark area to create volume. Notice how he did the reflection. Look at the simplicity of execution there where the trees seem to hang over the water. At the point where they meet, indigo was superimposed several times until it formed a dark intense line.

The dark area was not made dark with a single dense wash of colour but with a series of washes laid on at different times as the painting builds, tone over tone.

The halftone shadows, under the big tree on the right, were probably achieved with ultramarine, a little vandyke brown and a drop of emerald green.

Of course to be absolutely certain we would have to submit it to chemical analysis because colours are affected over time by light and by the yellowing of the paper. However, going by what I can see in this watercolour, I would choose the colours described.

Continuing our analysis: the shadows in the water on the left side were painted I would guess with ultramarine and a little carmine, applied directly to the white of the paper, and only interrupted by three bluish spots, hardly noticeable. In the foreground the reflections of the plants reappear.

Look at the ease with which Cézanne has laid on the colours of the reflections. With a little imagination you can guess the movement of his brush, how much water he used to dilute the colour and just when he decided to add a little more colour to increase its intensity.

The paintings of Cézanne have something of Michelangelo about them, an "unfinished" quality, of a stature so great as to seem – more than "unfinished" – "infinite".

A SPECIAL TECHNIQUE

Using Luisella Lissoni's watercolours on pages 66-67, 69 and 70-71 as an example, I want to show you a little known technique that forms a kind of bridge between watercolours and fresco painting. The derivation of watercolour from mural painting is obvious but few know how to use pure pigment (that is colour from powders), mixed only with water, without any binder.

But let's take it one step at a time.

First of all, you need some paper, and as usual you must be very careful with your choice. The support on which you paint is very important.

The success of your work and the range of effects you can achieve depend on how well it is prepared.

For the watercolours we are looking at now, Luisella used a Mi Teintes type paper and did her drawing with a Karisma colour pencil.

On top of the charcoal, which was not sprayed, she worked with a stiff squirrel's hair brush with a round tip, a brush that allows you to dissolve the black by rubbing it, creating shadows similar to what you can get with bistre.

Once the sketch was done, Luisella began to work with powdered colours, arranging them in little dishes like the ones used for turpentine in oil painting.

You should have as many little containers as you have colours and arrange them around the tile as if it were a wooden palette, using a little spoon to fill the containers with the powdered colours.

Luisella then took up some colour with a soft wet sable brush

and spread it over the palette, applying it directly without any binder.

She did the same thing with a second colour (mixing it with the first), and in this way continued until she had the first wash of tones on the paper.

When it had dried, she sprayed it with a fixative made for charcoal and pastels to preserve the colour (be careful here not to spray until it is completely dry). When the fixative was dry, using the same methods, Luisella did her second wash, and then sprayed again. She repeated these steps until she had finished her painting.

Remember to fix it after every wash of colour so that the colours that follow do not mix with those preceding them.

Luisella did the second watercolour with similar paper and a similar preparation to the first but with a different drawing technique.

This time she used a soft piece of charcoal, that is, classic drawing charcoal.

With the charcoal she made her drawing on a broad scale,

Following pages: Luisella Lissoni - Gorgonzola (95 × 40 cm).

65

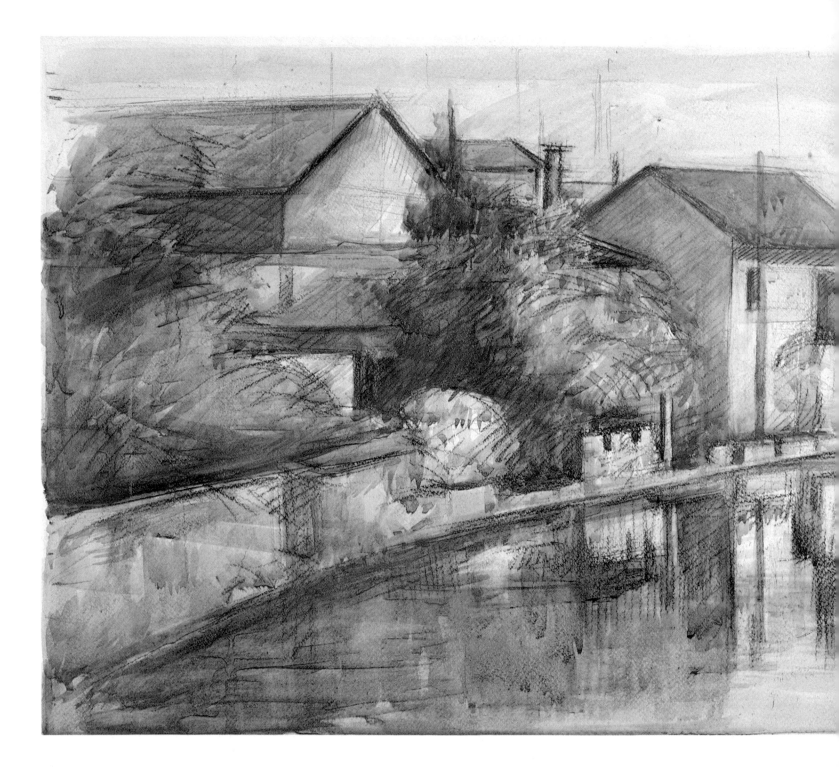

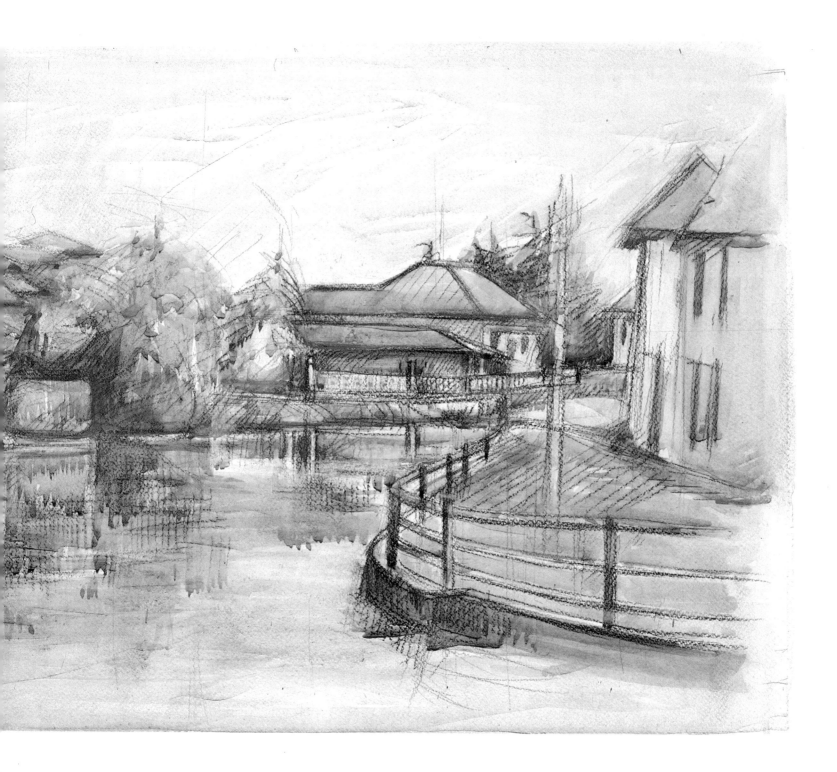

shading with the flat side to get the darkness of the shadows against the light of the bridge and the houses.

This kind of charcoal drawing should be sprayed with a fixative before going on to the painting stage.

A good fixative is one with a base of lacquer glue. Never use acrylic or synthetic fixatives but if you do not have the right kind of fixative, a hairspray makes a good substitute.

When you spray the drawing, hold the canister at least fifty centimetres from the paper and do not use too much or when you begin to paint, the water will be drawn out. If this should happen, do not panic. You only have to mix the water with a little ox gall which you can find in paint shops and which is used for all types of water-based paints.

In this watercolour charcoal plays an important role. If you attempt this technique, you must work boldly.

When the drawing is finished, spray it one last time, going over it gently afterwards with a finger and if you still find traces of black on your finger, then spray it again.

After she let her drawing dry, Luisella began to work with dampened powders, mixing them as if they were normal watercolours. Remember that these colours are much brighter than the others.

You must therefore use a lot of water and watch on that you do not create lumps which will break up into powder when they are put onto the paper.

Continuing on as in the other painting, Luisella used around four washes of very transparent colour.

There is another technique similar to the one I have just described which uses glue dissolved in water.

But first be forewarned. If you use this technique you will not need to spray the drawing with a fixative. The glue mixed with water takes the place of the fixative.

The glue to use is made of methyl cellulose, simple wallpaper paste diluted to a ration of one tablespoon per litre of water.

Let it rest for a day, stirring it often with a wooden stick (when you are mixing a substance for painting avoid metal objects; otherwise you may end up with an unpleasant surprise). If, after a day, the mixture seems too thick, add a bit more water. On the other hand, if it seems too watery, add a little more paste. After another half hour you can use it.

When painting you will have a very thick paste. In fact the paste seems very voluminous, but once it has dried it develops a very fine patina.

This is not in any case an easy technique to use but it should appeal to those who are confident of themselves and their abilities and have very clear ideas about the results they want to achieve.

To work with a mixture of paste and water means in fact working with a substance that is rather similar to gelatine, and obviously there will be certain difficulties involved. This technique, which requires the use of a rounded squirrel's hair brush, is very well suited to large-scale watercolours. The colour does not run as much as in the classic watercolour, tending to stay put, but nevertheless it still maintains its transparency and the final results are very original.

The techniques I am now describing are new techniques not used by other watercolourists. They are techniques we experimented with ourselves for the first time in our studio. Whether other watercolourists have tried them, I honestly do not know. I suggest you only try them when you feel confident that you are ready.

The colours mixed on your ceramic tile will have a gelatinous look which you can use as is if you want to do something at one go. Use brushwork similar to that which you see in the upper illustration reproduced on page 72 and the painting will end up looking like something between a watercolour and an oil painting.

On the other hand, if after you have mixed the colours with the paste you add more water, you will get a substance that is very similar to that used in classic watercolours (see the lower illustration on page 72). These two techniques can be used at the same time, especially in the layering of colours. Just take care when you are laying on the washes never to brush on a second layer until the first is absolutely dry.

In painting, as you must know by now, there are no fixed rules. I am offering only broad suggestions and it is up to you and your

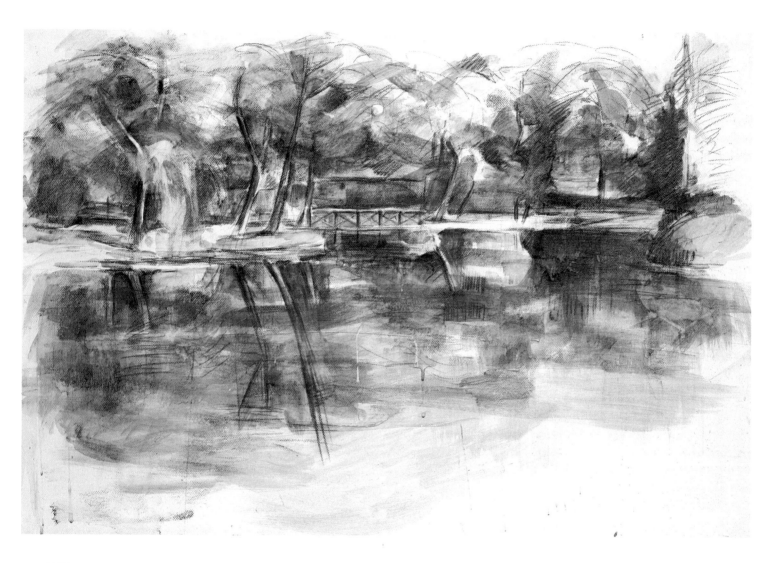

sensibility and imagination, to experiment with these new techniques. In fact, in general watercolourists are rather resistant to experimentation. I know many who have an almost maniacal relationship with their paper and colours – to the point

Luisella Lissoni - Reflections on Water (90 × 60 cm).
Following pages: Luisella Lissoni - Bridge on the Canal (95 × 50 cm).

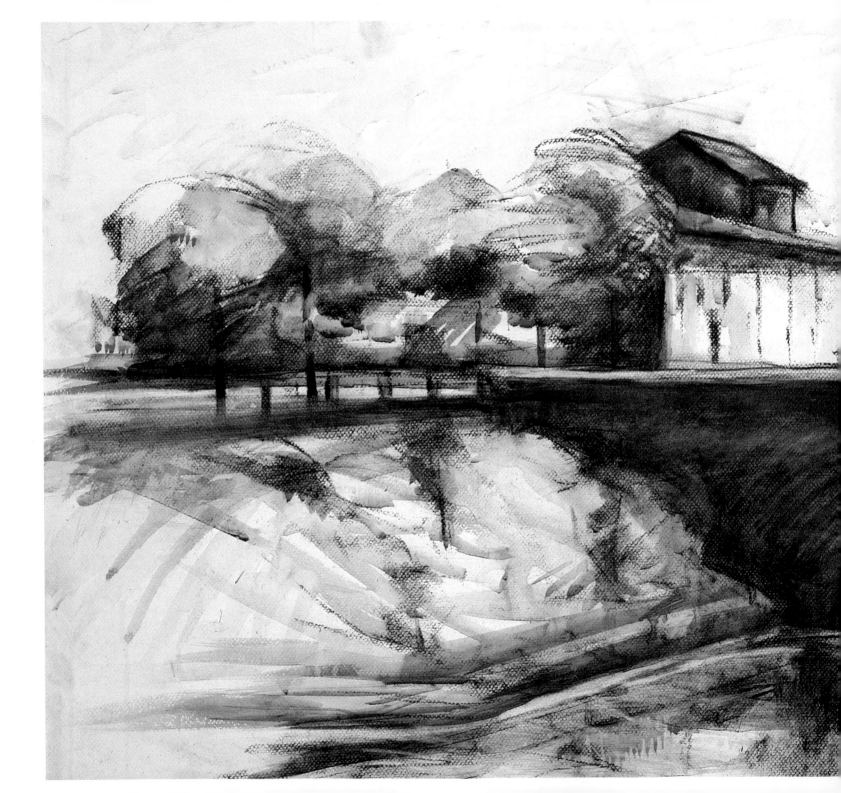

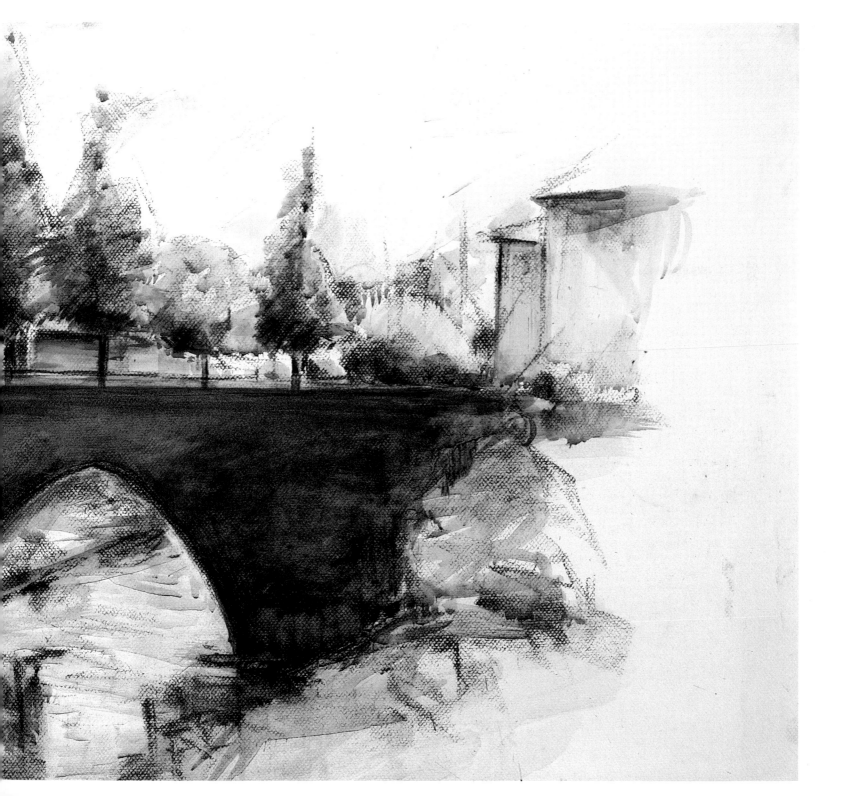

the paste and worked with the greens of the plants while working at the same time on the reflections. To get the effects of light she left empty spaces using the white of the paper, and she softened the brush strokes that were overloaded with colour with a brush dipped only in water.

THE LAKE BY ANDREA MAIOTTI

Andrea painted this little watercolour early one summer morning. It was done along the banks of a lake in Trentino. At that time of day, a light fog rises off the lake making everything look softened, toned down. The shapes of the pines and the lines of the riverbanks seem to be seen through frosted glass. To get this effect, Andrea sketched very generally the shapes of the pines and the line of the riverbank and then moved on immediately to colour, preparing on his ceramic tile a cool greenish bistre, obtained by mixing ultramarine, a little vandyke brown and a drop of light cadmium yellow.

With this colour he gave shape to the pines along the banks of the river and to the ones that you can see on the right in the foreground. He added a little permanent green to this colour, diluting it first with water, and with it brought the pines in the middle ground on the left to life.

Then with a very wet brush, he went over the entire wood, thereby giving it a feeling of depth.

Along the riverbank, he did a wash of very diluted vandyke brown and for the water itself he used a wash of very diluted ultramarine.

Then while the colour was still wet he went over it with more ultramarine, creating almost imperceptible reflections. On the water in the foreground, he made a few brushstrokes of ultramarine after the previous wash had dried.

Facing page: Andrea Maiotti - Fog over the Lake.

that some of them would never change the kind of paper they use.

My advice, however, is to get used to working with all kinds of paper and colours. You will build up a huge repertoire of experience, so problems will not throw you. Work happily with both large and small-scale paintings; with horizontal and vertical formats.

Many watercolourists prefer painting only landscapes, others still lifes, and others figures. Remember that specialisation is never a symptom of the search for perfection, but in some ways represents a limitation, just as it is a limitation to paint only with oils or with tempera. A true painter knows how to use all kinds of painting techniques, from oils to pastels to watercolours to tempera. This not only broadens your horizons but allows you to improve different techniques.

Let's see now how Luisella did the watercolour we are looking at. First of all, she blended a bistre, then used it as a wash, moistening her brush with the paste. Then she began to work with colour.

With the brush she spread a little of the coloured powder onto

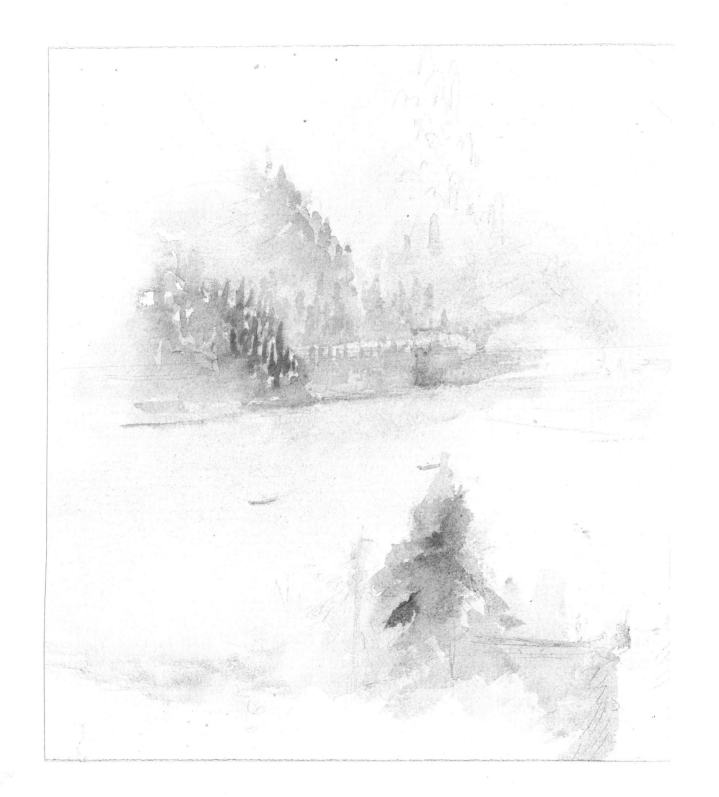

A SKETCH NOTEBOOK

It is a good idea for a painter to get into the habit of always carrying a sketchbook. Today you can find very good ones in art supply stores but at one time painters prepared them themselves, using scraps of paper leftover from their drawing sheets. For a painter, paper is a precious commodity. It is always treated with care: it is never wasted.

A good painter can work on any kind of paper. The notebook, preferably small in size, is the perfect training ground for this kind of exercise: Cézanne painted beautiful watercolours on very poor quality paper.

To make a small scale sketch, you must think about painting in a different way.

The true painter can be recognised by his sketches and the notes he has jotted down quickly.

In a certain sense a sketch is different; it is a drawing unaffected by changes in style over time.

Whereas you can easily see the difference between a painting by a Renaissance painter and a painter of today, you will see very little difference between a sketch made by an artist of the past and a modern one.

Doing a good sketch is not easy and for the best results you need the right tools. First of all, you must get used to "seeing by synthesis", that is, rising above details. If you really want to get the details down, do another sketch of the detail itself, next to your more general sketch.

To begin, make your drawing with a very sharp soft pencil, keeping in mind that your pencil should always be sharpened with a knife or a cutting blade and avoid at all costs sharpening it with an electric or manual pencil sharpener.

For a painter the pencil is as important as the bow is for a violinist and should be treated with the same respect.

While we are on the subject I will mention the kind of brushes you should use. I often see watercolourists who, when working on a small scale use very small brushes with few bristles. This is a mistake, a real sign of insecurity. When sketching I use very large brushes in relation to the dimensions of my painting. A big brush forces you to synthesize and work on a broad scale, to eliminate unimportant details.

You should also have a portable sketching box, preferably a

small one with the essential colours. Many boxes have a little built-in container for water, but do not worry about this too much. I have used all kinds of things. As a boy, I never had much money and my parents did not really support my desire to be a painter, so I used to buy my paints in loose pans and put them in a metal sweet box.

I used that system for many years and even now I am not very fussy and like my students to get used to working with all kinds of materials.

On the other hand I insist that they follow certain ironclad rules, for these are the only thing that a student can hold on to in order to get over his insecurity.

First of all, in order to understand technical facts you must learn by studying the sketches of the great artists (I am improperly referring to them as "sketches" instead of watercolour "studies" because in reality that is what they are: coloured sketches). So, get used to looking at the great painters. Do not limit yourself

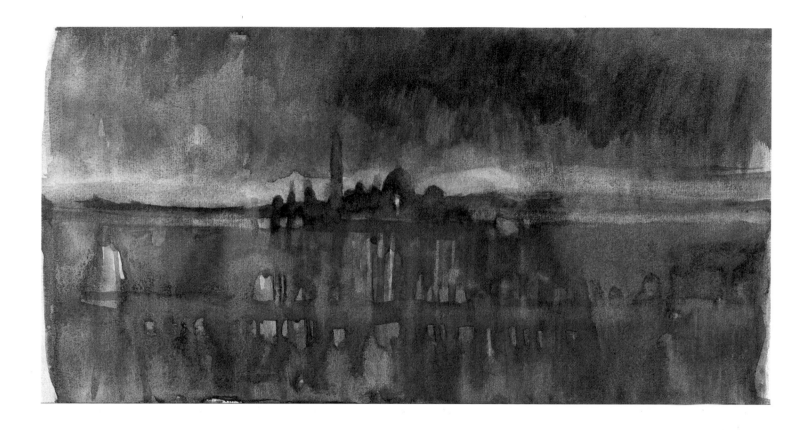

Ettore Maiotti - Venice in the Storm (actual size).

only to copying them, but also try to understand their lines and size.

But most important have faith in yourself; do things over and over again without losing heart. Ultimately you are the only one who can improve your work and this you must do through hard work, humility and a love of art.

Learn to draw and paint with vehemence, be quick in your execution, do not be afraid to make mistakes, do the same subject over and over again until you master it.

Learn to work methodically in your study and by instinct outdoors.

Among the many studies I have done there are numerous sketches made in the various Italian cities to which my work as a graphic artist has taken me.

Often meetings and appointments last the whole day so that towards evening, as a form of relaxation, I sometimes make quick sketches in whatever place I find myself, trying to put something down before the last bit of daylight is gone, taking

advantage of the twilight shades. Among these studies, I have selected a series of notes on evening reflections.

The dominant colour is blue indigo, or even ultramarine mixed with vandyke brown.

The first you see represents Venice painted one summer evening as a storm was approaching. The air was heavy and humid without the slightest breeze and an orange band on the horizon created a vaguely surreal atmosphere.

I continued the drawing quickly with a bistre I made from indigo and vandyke brown and created the profiles of the buildings against the light.

With various mixtures of ultramarine and bistre, I finally captured the evening atmosphere.

At this point I want to remind you of something very important in watercolour painting: the use of water. It is in fact a mistake to think that colour is more important. The most important thing is actually water, which you must have in order to work with colour and which thus becomes a kind of vehicle, simple but fundamental.

Get in the habit of diluting the colour heavily before washing it over your paper and as you paint, rinse your brush going back over the drops that collect under each brush stroke with just water alone and then drag them towards other areas of the same colour.

Try to get as much water as you can onto your paper shaping the areas according to the needs of the painting itself. Keep constantly in mind the idea that in a quick watercolour sketch, you should continually spread the colour washes with water, adding more colour to the parts that are weaker, without worrying much about leaving spots.

Wanting to make the sky darker but in an irregular way, I wet the paper with a wide flat squirrel's hair brush. For the reflections in the water I wet it so that it made vertical lines corresponding to the reflections.

With a brush loaded with a very diluted indigo I went back over the parts that I had gone over previously, with the results that you can see on page 75. I repeated this operation a couple of times until I had reached the intensity of colour I wanted.

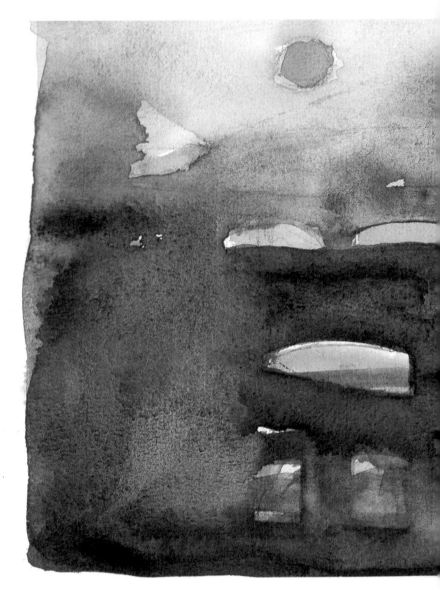

Ettore Maiotti - Bridges over the Arno (actual size).

76

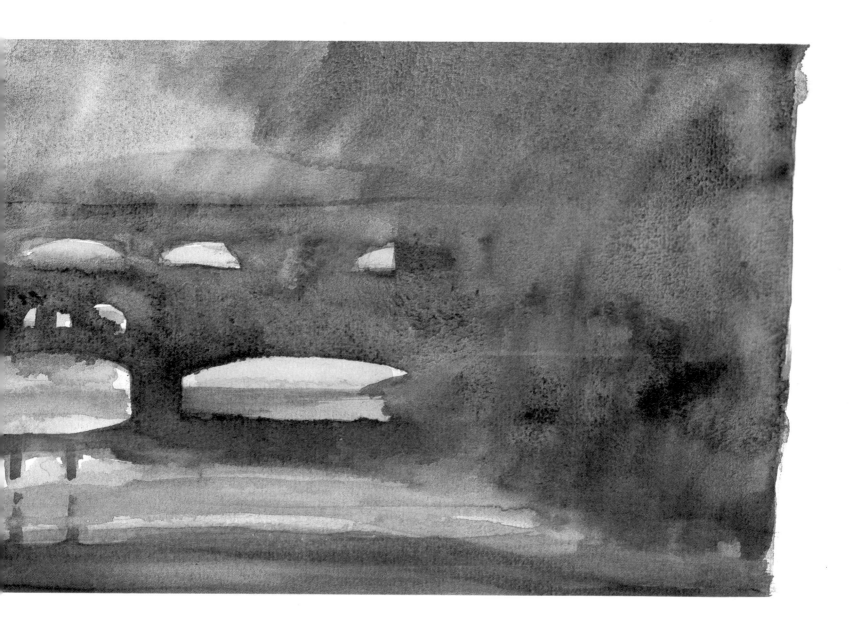

These operations should be quick and repeated rapidly. Do not try to complicate what should be simple; do not look for problems where they do not exist.

Another bit of advice. When you lay down a colour, go over it only once.

Do this with a sure touch, with no second thoughts. Whatever you do, do not go over it again and again with uncertain brushstrokes – if you do, the only result you will get will be to lose the brillance of the watercolour.

It has taken me many years of constant work to become the master of my materials and tools.

Only through constant application, making lots of copies, will you be able to work with ease, without suffering from shock each time you see a piece of paper soaked with water.

When I was young and stopped to watch someone working on a watercolour, I would think to myself that it did not seem very difficult to paint with this technique. You could do something very quickly.

On the other hand painters who worked with oil worked slowly and took days and days to finish and so it seemed to me that oil painting was much harder. When I became a watercolourist I realised that things were not as they seemed.

Of course you could paint a watercolour in five minutes but to be able to do it takes five years of constant work. In a way you could say that painting a watercolour takes five years and five minutes.

The right point of departure is a quick drawing like the one I did for the view of the Ponte Vecchio that is part of a series I did in Florence.

Florence is a city that seems made for watercolourists. It is impossible not to stop and paint. When you go there do not forget to take at least the minimum equipment with you so you can at least make some sketches.

As in the previous watercolours, I worked with a broad expanse, merging the zones of colour as much as possible. The time available to do a sunset is limited.

When the light reaches this point you should already have finished the drawing and begun the first washes of bistre. I began the drawing when the sun was still high and details of the bridge were still visible.

To achieve an effect similar to a widely separated chiaroscuro, I half-closed my eyes and managed to merge the values of the chiaroscuro.

Once the various values of the two blues of the bridges were synthesized, I continued with the yellowy orange of the river Arno, which reflected the rays of the sun.

Look at the way I was able to shape them with the brush, using the wet spots of water. Compare now these quick sketches with the large scale watercolours that we were looking at before and you will see the many ways one can paint a watercolour. One style does not preclude another.

In fact, I would advise anyone taking up this discipline to try everything. Every attempt, every experiment even if it does not work, helps you to grow.

I would like to make an observation along these lines: there is a tendency today at every level of society towards frivolity and foolishness and a wish to forget the past. Along with this there is a systematic tendency to deny all mistakes. Mistakes are perceived somehow as shameful.

But common sense still tells us that the best way to learn is through trial and error and I fully agree. Make your mistakes! Errors are more important than perfection: errors will force you to improve.

Anyone who does (or thinks he does) everything perfectly will be stuck in that perfection forever. I am constantly making mistakes and working from my errors.

You should always be trying and failing and trying again, working over and over on the same subject, building a professional memory.

A boat with its lights on stopped near a little bridge on Lake Garda. I had to be very quick so I stood near a lamp but positioned myself in such a way that it would not affect how I saw the colours on my palette and at the same time I would be able to see the colours of my subject clearly (keep in mind that you need to have about as much light over your paper as a candle provides).

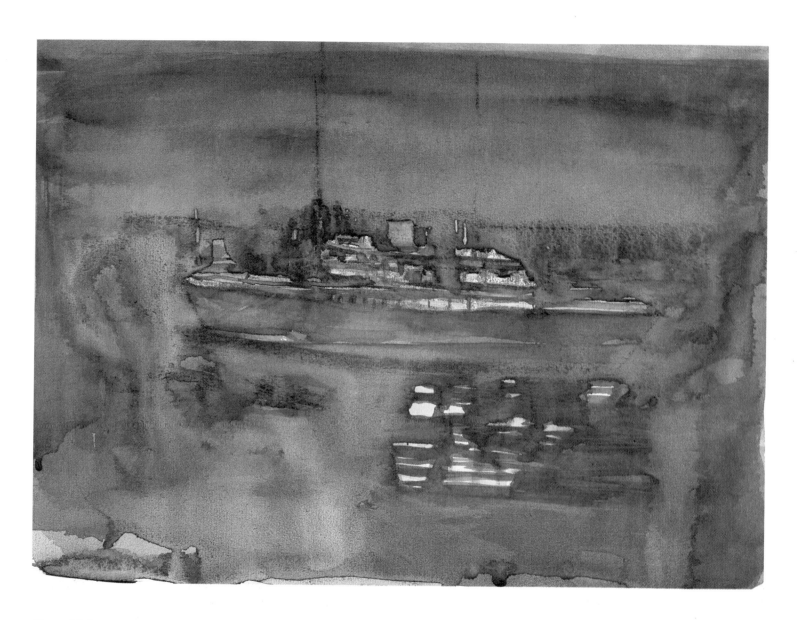

Ettore Maiotti - Boat in the Night (actual size).

For the drawing I took from my case a sanguine pencil that I had used in the past with interesting results, even though this was not my usual system of drawing with a pencil or charcoal. Sanguine, easily available in art supply stores as a pencil or a crayon is normally used when drawing nudes, or in the preparation of cartoons, and is on a par with charcoal or a Conté crayon or a Karisma pencil.

Many painters use them together. The red of the sanguine in

fact, mined from haematite, gives a very harmonious tonality that goes well with white or charcoal and gives outstanding results from an aesthetic point of view.

Let's go on now with our analysis of my drawing. The boat would soon move and this reduced the amount of time I had to draw it to about ten minutes, the time it would take to let off and take on passengers.

On the horizon the sky was tinged with a violet light reflected onto the water that the lake, like a mirror, reflected onto the mountains. An atmosphere to render with a dominant colour like indigo with a touch of ultramarine and cadmium yellow for the lights of the portholes.

These were my thoughts, my very practical thoughts, as I sketched out the drawing and in my head mixed the colours I would use. I must work using a lot of water, I thought, I need to decide between a big marten's hair brush with a round tip or a flat squirrel's hair brush, a number 14, if I remember well... At this point I began quickly with the background, pure indigo diluted with a lot of water, leaving the boat white.

I also left a white moire effect where the lights reflected because the movement of the waves did not allow me to establish a fixed point.

Then I let the colours settle for a few minutes and in the meantime I continued to observe the subject concentrating on the points in which the lake water reflected the vaporous lights.

I went over them with my brush dipped only in water. I let the paper absorb it for a few minutes and then I decided to mix indigo with a little ultramarine.

With a very big brush (number 20) and a lot of water I washed this colour over the whole sketch, including the boat, avoiding only the areas where the yellow lights were.

Then with the big brush I quickly went over the paper with cobalt violet which lightened the layer already washed with blue.

The boat in the meantime had finished picking up its passengers and it was leaving as I tried to memorise the exact position of the yellow lights. A few minutes passed, the boat had become a far off light in the middle of the lake and the watercolour was almost dry.

At this point I was able to add the yellow.

This kind of minute by minute account should help you understand how a watercolourist might think as he does a painting. First of all, you must learn not to reason mechanically or to work in sealed compartments.

While you draw you should already be planning your colours. While you are laying on your first wash you should already be thinking about your second, and so on.

This is the only way you will be able to work quickly enough because painting is made up of things that happen as consequences: the drawing is the consequence of your observation, the painting the consequence of the drawing.

VIEW OF THE SEINE IN PARIS
BY PAUL SIGNAC

Along with Georges Seurat and Odilon Redon, Paul Signac was one of the founders of the Salon des Independents. Signac was a great theoretician and he frequented a circle of intellectuals with anarchistic tendencies whose roots spread far and wide and at one time or another drew to it such vivid personalities as Courbet, Millet, Daumier and eventually even Van Gogh, at least in his later works. All were very demanding artists, perhaps the most demanding. In the past artists with anarchistic tendencies often had a strong formal training and great discipline, something quite different from today's anarchists who are anything but rigourous.

The watercolours by Signac started out as true notes, meant to capture an atmosphere which would then have been used as plans for larger Pointillist studies. He was a student of Seurat, who disappeared at the age of thirty-two leaving behind an important artistic theory which Signac, four years younger than he, followed zealously and in turn influenced such Fauvist painters as Matisse and Derain.

The watercolour reproduced on page 82 was drawn on a sheet of ivory-coloured paper and this is the reason why Signac used white for the clouds.

As we have seen already, white is usually never used in watercolours because the paper itself is meant to give the white tones. Of course this is not a fixed rule and it can be ignored when a certain effect is required.

Look carefully now, first of all, at the drawing that underlies the watercolour.

It was done quickly with a very soft pencil and it reveals a very expert touch.

Note the framing of the watercolour, the precision of the perspective, the houses in the background.

Only someone with a very good foundation in drawing and a lot of experience could have achieved such a result. I never tire of insisting on the importance of the drawing in a watercolour and I advise you to be suspicious of those teachers who neglect this part of your training. It is likely that Paul Signac started from the darkest zones in shadow so that he could follow with the autumnal colours of the trees and then the parched yellow ground. He rendered the trees farthest away with yellow ochre and white ochre and then with the same colours very diluted he did the houses and the trees beyond the bridges.

The reflections in the water were done with comma-like brush strokes of the same colour (bistre) as the trees and the bridges. If Signac had stopped at this point, he would have had a pretty, tonal watercolour but nothing more.

Instead, and this is what distinguishes a great painter, by bringing out the reds, transforming everything with red vermillion and covering very small surfaces with small quantities of this colour, without leaving any traces of it as reflections, he immediately draws our attention to the right hand area of the foreground.

With light cadmium yellow and a few cerulean blue spots he filled in most of the rest of the right side of the riverbank. Finally for the clouds, he used zinc white.

In watercolours, if you must use white, you should always use zinc white, as it is more transparent, rather than titanium which is more opaque.

Look carefully now at the lines of the pencil and those of the brushstrokes.

They all have a vertical movement and certainly anyone who is familiar with Signac as a Pointillist can recognise his touch here. This is an example of how versatile a good painter is and how he can thus explore as he pleases in his studies and sketches.

Turner himself, considered as the water colourist "par excellence", also uses white on water colour paintings.

He resorts to this device when he works on paper which is not white, or every time he wishes to obtain special effects.

Many water colourists consider the use of white as heretical. In fact, it is necessary to limit the use of white: however, in my opinion, the main thing is the final result.

The painter's sensivity will ultimately decide on the picture's value, with or without water.

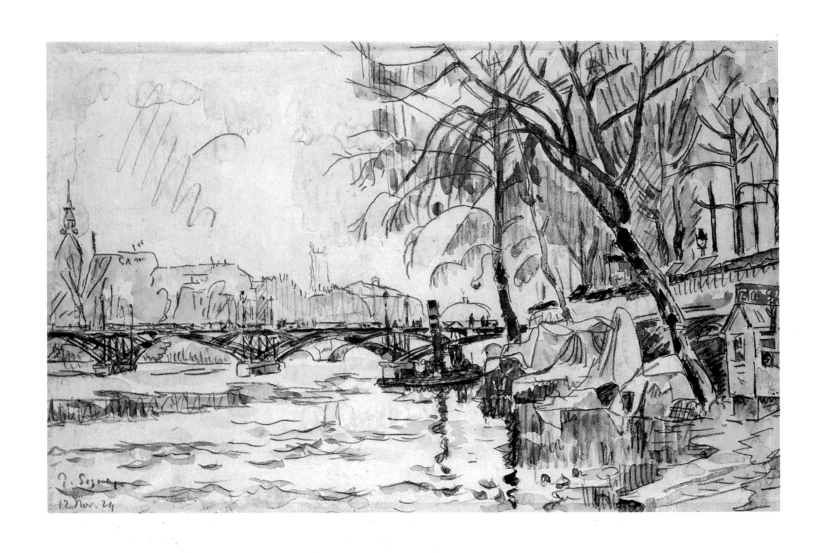

Paul Signac (1863-1935) - View of the Seine in Paris.
Watercolour on paper (26 × 31 cm).
Hamburger Kunsthalle, Hamburg.

THE PORT OF COLLIOURE
BY HENRI MATISSE

Matisse was the leader of the Fauves, the painting movement influenced by the Pointillists and by the Symbolists and specifically by Paul Signac with whom Matisse worked at the turn of the century in the south of France.

Painting movements always arise out of other earlier movements as well as contacts among the painters themselves as they share new ideas and techniques with each other and participate in experiments with colleagues of the same tastes and tendencies. In this way in the past new stimuli were born, something that happens less today when so many painters close themselves off to others, wanting – or so it seems – to guard who knows what secrets. What this more often hides is an inferiority complex and not a desire to move ahead and improve.

As we follow along our separate paths we will find out who among us are the best. When we do, we must accept this and recognise them as such, champion these leaders and try to learn as much as we can from them. This will greatly enrich us all. Painters have always done this, especially those from the last half of the nineteenth century and the beginning of the twentieth. It was only with the advent of the so-called consumer society that the figure of the artist as loner was born, going his own way, not following any movement.

There is nothing to object to in this but one thing is certain, especially as regards painting and watercolours: if you do not have contact with others it is hard, very hard indeed, to develop your own creativity and your own expressive techniques.

But let's go back to Matisse. The Port of Collioure reproduced on the following page represents a notable example of Fauvist art.

The painting, as you can see, is divided into two zones of complementary light and colour with the right side painted with pure ultramarine and emerald green and the left with yellow and yellow orange.

On the far left there is some emerald green mixed with a little cadmium yellow where Matisse painted some waves of a lovely warm green. In the foreground the tones of the two anchored boats stand out, one green and one yellow. And here you can see the beginnings of avant-garde painting.

Try looking at this painting with your eyes scrunched up and you will see what depth he was able to create: how the warm yellows of the waves in the foreground followed by a red wave, seem to come forward in relation to the lightest yellow strip and yet seem cooler (with respect to the foreground) when they are next to the ultramarine of the horizon, seeming to go beyond it optically.

There are very few colours used in this watercolour, just ultramarine, carmine, cadmium yellow, emerald green. The others come from mixing these three.

The colours of the little boats in the foreground and the green of the sea to the left are achieved by mixing emerald green with cadmium yellow, the orangish red by mixing carmine and cadmium yellow, the violets by mixing carmine and ultramarine. As you see, this is a simple watercolour both in its execution and its chromatic range and it demonstrates what I have said so often. That is, that a painting can say a lot with few strokes. This is a result which is arrived at with patience and in stages, eliminating the superfluous little by little while increasingly emphasising the essential.

In any case, one thing is certain: at times it is more interesting to leave a painting with the sense that it is not finished, that the exasperating search for formal perfection is not over. The Fauvist painting was based on optical contrasts created with complementary colours, a red for example juxtaposed with a green, an orange juxtaposed with a blue, or a yellow with a violet.

Remember that each colour has its own specific complement: a particular yellow will not have any violet as its complement; it will have one in particular. And so it goes.

If you want to find out more about this, you should read Goethe's colour theory: all painters from the Impressionists on have drawn from this and other theories. This is very important for those who want painting to be more than just a hobby and wish to learn to "read" colours.

Henri Matisse (1869-1954) - The Port of Collioure, 1905 - Watercolour on paper (13 ×21 cm).
The Baltimore Museum of Art, Claribel and Etta Cone Collection, Baltimore, Maryland.

Pages 85-86-87: Ettore Maiotti - Sketches from his Notebook of 1968.

A WATERCOLOURS NOTEBOOK

The idea for writing this book came to me one day when I was straightening up my studio and I came across a small notebook. As a boy I had used it to make sketches and copy the things around me that caught my eye. It was in the small notebook that I found a series of studies I had made whilst trying to figure out how to paint water.

They were my first watercolours and a lot of time has passed since then but I remember perfectly how and why I did them.

In the summer, during my holidays I had travelled around Italy on an old bike breathing its last. In those days I did not want anyone to see me painting at an easel because having people stop and stare irritated me. So I would look for hidden corners where I could paint in peace. I needed to concentrate and being left alone was a big help.

I worked with a small portable paint-box and used a no. 6 sable-hair brush with the handle shortened so that it did not measure more than 10 centimetres long. When I found a spot, I would stop my bike and, leaning against the handlebars, begin to paint. Many of my friends took pictures and then copied from the photos but I have always been against such a mechanical way of expressing feelings. I always preferred my notebook to a camera because I do not think a mechanical instrument can give you the same feeling as something you have made with your own hands.

The watercolours, reproduced in actual size on these pages, are part of that notebook I kept when I was young.

I have chosen works in which I was trying to capture reflections on water.

Looking at them now after so many years is like looking at old friends with whom I have lost touch. This notebook had ivory-coloured paper; the best kinds were the ones made of fairly poor quality paper.

I often used the backside of the sheet, the side without the little squares but the other side also worked well.

In those days I was not trying to be subtle. I had to learn to paint on everything. As I painted these first studies, even though the results were mediocre, I felt a growing desire to learn more about technique.

These notes were very useful. I learned to work quickly, I learned to synthesize drawing with colour and this knowledge has stood me in good stead.

Each new way of using the brush was a sign that I had learned something. It was the training ground where I practised my skills.

Even today I always carry a notebook with me and the notes I take in it continue to be an important source of inspiration for me, a kind of visual memory.

VENICE IN THE SNOW

Venice is so beautiful that not even the zeal of modern architecture or corrupt administrators have managed to destroy it completely.

Venice covered with snow is an extraordinary sight. I was in Venice and was supposed to leave that morning. It had snowed for a few hours and the sky was grey, the grey that one sees only when it snows.

The snow was coming down in very tiny flakes and I thought that it would be lovely to paint. But it was late, so I packed my bags and started off to catch the vaporetto to take me to the station.

On the way I passed the spot that you see reproduced here in the painting and I could not resist it.

Sitting on my suitcase with my umbrella tucked down my back inside the collar of my coat, I began quickly to paint the sketch. Luck was with me, even down to my equipment for "emergency first aid painting".

The mist created by the falling snow created a Pointillist-like effect.

This is what I had to keep in mind while I was putting down my first outline of the sketch. A few minutes later the sketch was finished.

When you set yourself to this type of exercise you should let your hand run free.

More and more often these days I draw with my eyes fixed on the subject and do not even look at the paper.

Once you have a great deal of experience it becomes second nature.

I brushed a wash of grey (bistre) over the whole sheet and then in the darker areas I let drop spots of a darker colour.

Ettore Maiotti
Venice Covered
with Snow
(actual size).

88

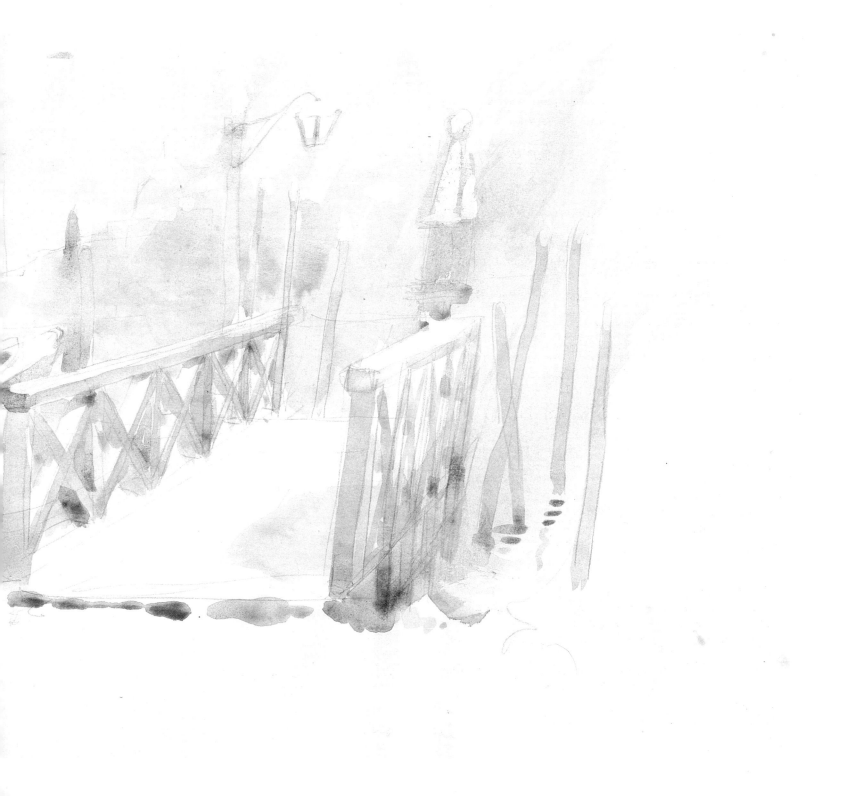

With the tip of the brush, using yellow ochre mixed with a little burnt ochre, I got the tones of the wooden bits and then I painted the boat mixing cerulean blue with a little ultramarine. Since the paper was straw-coloured, I used zinc white to give the feeling of snow.

These little sketches should take no more than about half an hour, otherwise they lose their freshness.

As you have seen, there are many different techniques used in watercolours and each painter will choose the one best suited to his temperament.

But it is always good to know about others because one complements the other and also because the more techniques you know the more possibilities you will have to control your colours. Experience in the end is the best teacher. This is no more than a bit of advice that I hope you will take into account. In any case, I have enjoyed sharing it with you.

From a Notebook of Giorgio Brenni (actual size).

INKS AND COLOURS FOR SKETCHING
from the notes of the restorer Sandro Baroni

Many of the old masters used to sketch out their first compositional ideas using monochromatic tints, especially browns or greys.
To make these monochromes they used pigments or inks which they made up in various ways.
Let's look at a few.

Bistre. Bistre is one of the oldest brown pigments. At one time it was obtained by pounding the soot deposits found in the chimneys of old fireplaces.
If you would like to try making some of this wonderful colour yourself – which can give you, depending on how much you dilute it, tones between black and brown – scrape a little soot from the hearth of a chimney where there has been a wood-burning fire, and with a little gum arabic dissolved in water in a ratio of 1 to 3, pound it on a bit of glazed glass until it is very fine with a pestle or a metal spatula.
For even better results, to every spoonful of soot add two drops of linseed or nut oil previously mixed with a little ox gall. Mix it immediately with the usual gum arabic and water.

Sepia. Today manufacturers of paints can generally provide sepia as a pigment, artificially mixing its brown colour, or else mixing bone black with some natural earth browns.
However, these brown pigments have very little to do with the natural colour extracted from the black ink sac of certain marine animals.
It is not terribly difficult to get hold of real sepia. There is plenty of it, especially near the sea.
If you are ever in Italy, you can even buy genuine sepia in little packets in the supermarket.
The black ink sac, once you have extracted it, should be mixed with equal parts water to which it is best to add a few drops of non-alcoholic disinfectant.

Leave it to dry in the air and then crush the sediment with gum arabic.
You can use it either as a paste if you let it dry in a bottle cap, or as a block if you put it in a tiny container.

Various brown inks. In the nineteenth century, some painters used brown inks diluted with various things to prepare mono-chromatic compositions.
A mixture often used both for drawings done with pen and in sketches done with a brush, was a combination of a brown corrosive acid for wood mixed with water, which was then used as an infusion in white wine and a little gum arabic. In its constituent properties, this ink follows, in effect, in the foot-steps of the oldest writing inks composed of tannin dug out of the gall of oak trees, which was then replaced by a corrosive acid, wine and gum arabic. One last lightstable brown can be made from the condensation that forms from the slow boiling of toasted barley. When it has reached the concentration you want, that is, of a thick ink, the liquid should be allowed to cool and then filtered into a little bottle, with a few drops of non-alcoholic disinfectant added to it, and capped.

ADDITIVES FOR WATERCOLOURS

In painting watercolours different substances added to water can produce special effects, the purpose of which is both to make the work easier and technically affect the final result.

Water tension breakers. These are special substances, which can modify the surface tension of the water. In simpler terms they can make the penetration of liquid on a porous surface like paper, easier, favouring its absorbency. Often used for this is ox gall which you can find at an arts supply store, clarified and ready for use.
As a substitute if you cannot find ox gall, beer will produce good results. Take some beer and leave it exposed to the air for a few days until it turns rancid.

Then over a slow fire, bring it to the boil, reducing the liquid for at least fifteen minutes, and then filter it through a piece of cloth. To conserve it for further use, put it into a glass bottle and close it tightly.

A few drops of non-alcoholic disinfectant in a glass of water will give similar results to those given by ox gall or other weak water tension breakers, without altering the tints of your composition or affecting its conservation.

Gels. For certain effects it is possible to add a small amount of gelatine to water, which increases the viscosity of the liquid, slowing down its drying time.

For this purpose you can use methyl cellulose which is ordinary wallpaper paste sold in powder form in paint stores. Dissolve two grams in half a litre of water, leaving it for at least 24 hours to expand.

Add a few drops of non-alcoholic disinfectant and keep it in a bottle or a small jar with a wide neck covered with a screw-on cap.

When you are ready to use it dilute it with plenty of water as you need it, mixing it well.

Retardants. To slow down the drying rate of the paper and the tints, many watercolourists add a few drops of glycerine to a glass of water.

Similar effects were obtained in the past by dissolving half a teaspoon of honey in half a litre of water.

This particular practice can be used effectively only with heavy weight paper that is highly absorbent.

This is because the honey rarely dries and thus tends to leave a somewhat sticky surface on the painting if it is not well-absorbed.

This facilitates the formation of ripples on lighter weight sheets because of the different rates of absorbency of the liquids.

You can also find special watercolours in shops to which honey and gum arabic have already been added in small quantities at the time the paint is ground for blocks.

Fixatives. In some cases it is necessary to preserve your watercolour once you have finished it.

To do this, you can use the same spray cannister of fixative you would use for drawings, charcoal or pastels, the kind made with natural or synthetic resins dissolved in the appropriate solvents.

Keep in mind though that fixatives tend to heighten the tones of colours a bit and modify the natural quality of the watercolour. The resin fixatives tend to yellow with age so only use them when you think it really necessary and always with moderation, in light layers, and well distributed.

If you want to make your own fixatives, using traditional recipes of nineteenth- and twentieth-century painters: dissolve a spoonful of whitened gum lac in about a quarter of a litre of ethyl alcohol in a bottle.

Close the bottle tightly and let it set for at least a day for the resin to dissolve completely.

Apply the fixative with an atomiser, shaking it well before using. Repeat the operation if necessary.

On very thick absorbent paper you can preserve your watercolour and get special effects with the fixative by spraying the surface with about ten grams of paraffin dissolved in a decilitre of essence of petroleum or rectified benzine. This encaustic substance once dry makes the surface resistant to water and also makes it glossy but it can considerably alter the appearance of your work.

As a rule, remember that with this particular fixative, the paper becomes darker, the paint deeper and more transparent, and the surface more satiny.

PIGMENTS

Pigments in powder form, finely crushed with a little gum arabic and water, are the substances used for the basic techniques of watercolour paintings.

Colours prepared in this way can be used as liquid pastes or they can be dried in small containers to form ready-to-use blocks.

The pigments can be of a natural origin (mineral, vegetable or animal) or they can be artificial, the products of chemical synthesis.

The pigments should be very finely granulated or in powder form and one must pay close attention to their stability when exposed to light.

Non-lightfast pigments – and it is always better to keep them separate from more stable pigments – should only be used in sketchbooks or with other supports where the painting will obviously be protected from exposure to ultraviolet rays.

Below is a table, listing some of the most important pigments used in watercolour painting, by colour category.

As you see the gradations of tones are very wide.

However one should be careful to avoid certain mixtures that, especially with watercolour techniques, can create chromatic changes.

In general terms, remember that white and red ochre tend to change when exposed to the air, forming a darker patina. Prussian blue can turn brown.

Generally speaking, pigments that are lead based (white lead, red lead, chrome yellow, litharge) should not be mixed with sulphides (red ochre, ultramarine, chrome red or yellow, orpiment) just as prussian blue changes when in contact with pigments with a chrome base.

TABLE OF PIGMENTS

WHITES

ZINC WHITE	Zinc sulphide
BARIUM WHITE	Barium sulphate
TITANIUM WHITE	Titanium dioxide

YELLOWS

CADMIUM YELLOW, PALE	Cadmium sulphide
CADMIUM YELLOW, DEEP	Cadmium sulphide
INDIAN YELLOW, IMITATION	Yellow benzidine
	Anthraquinone
NAPLES YELLOW	Lead antimoniate
	Yellow dyarilide
	Cadmium sulphide
CADMIUM ORANGE	Cadmium sulphoselenide
GAMBOGE, IMITATION	Yellow benzidine
YELLOW OCHRE	Hydrated ferric oxide
GOLDEN OCHRE	Natural ferric oxide
STIL DE GRAIN YELLOW	Nickel complex
	Anthraquinone
RAW SIENNA	Natural earth

REDS

ALIZARIN CARMINE	Anthraquinone
MADDER LAKE, PALE	Anthraquine
	Quinacridone
MADDER LAKE, DEEP	Anthraquinone
	Polysolphide of aluminium
	sodium silicate
ROSE MADDER	Xantene PTMAU
CADMIUM LIGHT RED	Cadmium sulphoselenide
CADMIUM DEEP RED	Cadmium sulphoselenide
ENGLISH RED	Synthetic ferrous oxide
DRAGON'S BLOOD	Natural earth containing calcium
	Quinacridone
TERRA DI POZZUOLI	Synthetic ferrous oxide
	Natural earth
BURNT SIENNA	Natural earth containing calcium
LIGHT VERMILION	Mercuric sulphide
DEEP VERMILION	Mercuric sulphide

GREENS

TERRE VERTE	Natural earth
	Calcium oxide
CADMIUM GREEN	Calcium suphide
	Phthalocyanine
COBALT GREEN	Calcium oxide
	Zinc
PHTHALO GREEN	Phthalocyanine
PERMANENT GREEN	Hydrated chromian oxide
	Cadmium sulphide

EMERALD GREEN	Hydrated chromian oxide		Dioxazine
	Phthalocyanine chlorinate	**COBALT VIOLET**	Cobalt phosphates
VERONESE GREEN	Zinc sulphide		Quinacridone
	Barium sulphide	**QUINACRIDONE VIOLET**	Quinacridone
	Phthalocyanine chlorinate from Hansa 10G		

BROWNS

SAP GREEN	Iron nitrous beta naphthol		
	Yellow dyarilide	**VANDYKE BROWN**	Bone black
			Natural earth containing calcium

BLUES

		SEPIA	Bone black
CERULEAN BLUE	Cobalt aluminium chrome oxide		Natural earth containing calcium
LIGHT COBALT BLUE	Cobalt aluminate		Natural earths
DEEP COBALT BLUE	Cobalt aluminate	**STIL DE GRAIN BROWN**	Phthalocyanine chlorinate
PHTHALO BLUE	Beta phthalocyanine		Yellow benzadine
MANGANESE BLUE	Barium manganate		Anthraquinone
ULTRAMARINE	Polysulphide of sodium alumino silicate	**BURNT UMBER**	Natural earth containing calcium
PRUSSIAN BLUE	Ferric ferrocyanide	**RAW UMBER**	Natural earth
INDIGO	Ferric ferrocyanide		
	Carbon black		
	Anthraquinone		

BLACKS

		PAYNE'S GREY	Polysulphide of aluminium sodium silicate

VIOLETS

			Bone black
VIOLET LAKE	Polysulphide of sodium alumino silicate	**IVORY BLACK**	Bone black

VEGETABLE COLOURS OR JUICES

In the Middle Ages, a medieval monk named Heraclies, writing in a work on illuminated manuscripts, described the various colours one could extract from the petals of flowers. Leonardo da Vinci in his *Treatise on Painting* describes how he extracted a red ink for painting from the petals of poppies. Paolo Pino, not many years later, mentions a painting made with vegetable juices, defining it as "moorish", that is as something coming from Islamic culture and tastes. The procedure for extracting vegetable dyes for use in painting is a very old one. Working with water and juices or vegetable extracts is easier than one might think. If you want, you too can extract colours from easily found plants. The principle of colour extraction is to make an infusion with a dried or fresh plant and then, depending on what kind it is, mince it and boil it in a little bit of water. You then filter it and boil it again to reduce it further. The liquid you obtain can be used directly on paper, like any ink.

However, it is a good idea to add a little barium sulphide, which comes in little packets sold at a chemist's, to the solution and also add a half part of alum. The vegetable colour will precipitate in the barium sulphide, forming a coloured lacquer. Let the colour decant and throw away the excess water. Crush it with a little gum arabic and use it like an ordinary watercolour.

Always remember that these natural vegetable dyes are not very lightfast and can only be used in notebooks or sketchbooks. As time goes by, you will become more experienced at making tints, gathering the herbs and plants you need to make dyes yourself. However it is useful to know that many exotic dried herbs and plants for making dyes and vegetable colourings can easily be found in a herbalist shop.

TABLE OF DYES

REDS

HENNA	(ALKANNA TINCTORIA)	Roots
RED WOOD	(CAESALPINA CRISTA)	Wood chips
RUE	(RUTA GRAVEOLENS)	Roots
LADY'S BEDSTRAW	(GALIUM VERUM)	Roots
COCHINEAL INSECT	Dried insects	
DYER'S MADDER	(RUBIA TINCTORUM)	Roots

PINKS

HEDGE BEDSTRAW	(GALIUM MOLLUGO)	Roots
PRICKLY PEAR	(OPUNTIA CACTACEA)	Fermented juice
RED SANDALWOOD	(PTEROCARPUS SANTALINUS)	Sawdust

ORANGES

MAHONIA	(MAHONIA ACQUIFOLIUS)	Roots and branches
TAMARISK	(MYRICA GALE)	Entire plant
LADY'S MANTLE	(ALCHEMILLA VULGARIS)	Leaves
EUROPEAN LARCH	(LARIX DECIDUA)	Needles
LILY OF THE VALLEY	(CONVALLARIA MAYALIS)	Leaves
PRUNUS	(PRUNUS DOMESTICA)	Bark
HENNA		

YELLOWS

BIRCH TREE	(BETULA ALBA)	Leaves
POPLAR	(POPULUS ALBA)	Leaves
GARDEN SORREL	(RUMEX ACETOSA)	Entire plant
APPLE	(PYRUS MALUS)	Bark
BILBERRY	(VACINIUM MIRTILLUS)	Entire plant
PEACH TREE	(PRUNUS PERSICA)	Bark
PRIMULA	(PRIMULA OFFICINALIS)	Flowers
LIME TREE	(TILIA PLATYPHYLLA)	Leaves
IVY	(EDERA ELIX)	Leaves
CHAMOMILE	(ANTHEMIS TINCTORIA)	Flowers
HAIRY CHERVIL	(CHAEROPHYLLIUM HIRSUTUM)	Leaves

YELLOWS

MARIGOLD	(TAGETES)	Flowers
COMMON HORSETAIL	(EQUISETUM ARVENSE)	Entire plant
SUNFLOWER	(HELIANTUS ANNUUS)	Flowers
COMMON PRIVET	(LIGUSTRUM VULGARE)	Branches
COMMON MULBERRY	(MORUS NIGRA)	Leaves
NORWAY MAPLE	(ACER PLANTANOIDES)	Leaves

GREENS

SWEET BAY	(LAURUS NOBILIS)	Leaves
SILVER BIRCH	(BETULA ALBA)	Leaves
HEATHER	(CALLUNA VULGARIS)	Entire plant
FIG	(FICUS CARICA)	Leaves
BEARDED IRIS	(IRIS GERMANICA)	Flowers
HORSE CHESTNUT	(AESCULUS HIPPOCASTANUS)	Leaves
RASPBERRY	(RUBUS IDAEUS)	Entire plant
MALLOW	(MALVA SILVESTRIS)	Entire plant
BILBERRY	(VACCINIUM MYRTILLUS)	Entire plant
WALNUT	(JUGLANS REGIA)	Leaves
GREAT PLANTAIN	(PLANTAGO MAIOR)	Leaves
DYER'S ROCKET	(RESEDA LUTEOLA)	Entire plant
BLACKBERRY	(RUBUS FRUTICOSUS)	Entire plant
SAW-WORT	(SERRETULA TINCTORIA)	Entire plant
BUCKTHORN	(HERAMNUS CATHARTICA)	Pods
TANSY	(TANACETUM VULGARE)	Entire plant

BLUES

INDIGO	(INDIGOFERA TINCTORIA)	Powder
BILBERRY	(VACCINIUM MYRTILLUS)	Pods
ELDER	(SAMBUCUS NIGRA)	Pods

VIOLETS

LADY'S BEDSTRAW	(GALIUM VERUM)	Roots
LOGWOOD	(HAEMATIXYLON CAMPECHIANUM)	Wood chips
BUTTERCUP	(RANUNCULUS ACRE)	Entire plant